# The Great Wave:

THE INFLUENCE OF JAPANESE WOODCUTS ON FRENCH PRINTS

**1** KATSUSHIKA HOKUSAI, 1760–1849

*Great Wave off Kanagawa. Color woodcut from the series*
Thirty-six Views of Mount Fuji. *Late 1820s*

The Metropolitan Museum of Art. Ex. coll. Howard Mansfield.
Rogers Fund, 1936. no. 2569

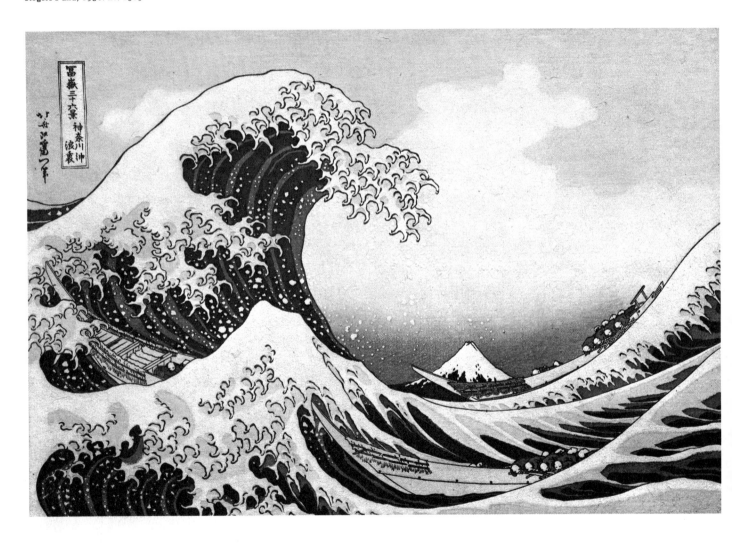

# THE GREAT WAVE: The Influence of Japanese Woodcuts on French Prints

**Colta Feller Ives**

Associate Curator, Department of Prints and
Photographs, The Metropolitan Museum of Art

THE METROPOLITAN MUSEUM OF ART

*Distributed by* New York Graphic Society

Designed by Peter Oldenburg
Type set by Finn Typographic Service, Inc.
Printed by Nicholas/David Lithographers
Bound by Publishers Book Bindery, Inc.

LIBRARY OF CONGRESS CATALOGING IN PUBLICATION DATA

Ives, Colta Feller.
   The great wave: the influence of Japanese woodcuts on
French prints.

   Bibliography: p.
   1. Prints, French—Exhibitions. 2. Prints, French—Japanese
influences. 3. Impressionism (Art)—France. 4. Ukiyoe. I. New
York (City). Metropolitan Museum of Art. II. Title.

NE 647.6.I4I93                  769'.944                  74-16187
ISBN 0-87099-098-5
ISBN 0-87099-228-7 (pb)

# Contents

# Preface

The role of Japanese prints in the history of impressionist painting is a curiosity that has long attracted scholars. Japan's effect on European decorative arts, especially ceramics, has also drawn attention. But little recognition has been paid the influence of Japanese woodcuts on French prints—a late-nineteenth-century phenomenon in which the transfer of eastern manners to western means is strikingly clear, for the message was transmitted in the same medium: ink pressed upon paper. Although some of the most thoroughly Japan-persuaded artists painting in France in the last century—notably Monet and van Gogh—made few, if any, prints, the period is rich in etchings, lithographs, and woodcuts steeped in *japonisme*.

The extensive collections of French and Japanese prints in The Metropolitan Museum of Art (fortuitously stacked within a few steps of one another) have made it possible to bring together some of the finest examples of Ukiyo-e woodcuts and their western counterparts to illustrate the oriental lessons the French printmakers learned. The prints were originally selected for exhibition at the Metropolitan between January 14 and March 9, 1975; that their juxtapositions have also become the structure of a book is due to the enthusiasm and support of many individuals and institutions, all of whose thoughtful assistance is heartily appreciated.

The privilege of studying the Japanese prints in the Museum's collections and planning the exhibition was granted through the indulgent cooperation of the Department of Far Eastern Art; Jean K. Schmitt, Julia Meech-Pekarik, and Graduate Assistant Sarah Bradley gave expert advice to me and valuable corrections to my text.

Every member of the Print Department staff contributed in some way toward the book and exhibition; thanks are due A. Hyatt Mayor, Janet S. Byrne, Mary L. Myers, Weston J. Naef, Suzanne Boorsch, David Kiehl, Edmond Stack, Mary Ann Elliott, and in particular, Dita Amory, who spent a summer ably troubleshooting for the project. Other members of the Museum staff who aided at crucial points along the way are John Walsh, Jr., Natalie Spassky, James Pilgrim, Katharine H. B. Stoddert, John K. Howat, and Kay Bearman.

In 1972 the Museum generously granted me the opportunity to research *japonisme* in French libraries and museums. For courtesies extended to me while I studied in their country I am indebted especially to Jean Adhémar and Nicole Villa, Département des Estampes, Bibliothèque Nationale, Paris.

An excursion to Japan in early 1974 was made possible by the graciousness of the Yomiyuri Shimbun and Dr. Chisaburoh Yamada, Director of the National Museum of Western Art in Tokyo.

My research in New York was facilitated by Professor Theodore Reff, Columbia University, and Roberta Wong, Prints Division, New York Public Library.

The book would never have come to press had it not been for the patient attentions of Bradford D. Kelleher and Margot Feely of the Museum's Publications Sales and Production departments; of Peter Oldenburg, who is responsible for the design; and of William F. Pons, who photographed the prints in the Museum's collections. Polly Cone brought uncommon care and intelligence to both the editing and production of the book; I am grateful for her presence on every page.

It is to John J. McKendry, Curator of Prints, who has shared my fascination with this subject, aimed me in the right direction, and packed me off to the magic of Japan, that this work is dedicated.

C.F.I.

# CHRONOLOGY
# OF RELATED EVENTS

## 1542

First Europeans known to enter Japan are three Portuguese navigators blown off course from Macao. They set up agreement that establishes flourishing trade

## 1640

Shōgun Ieyasu Tokugawa bans foreign trade and travel, expels westerners from Japan; only a few Dutch traders remain

## 1812

Some Japanese woodcuts brought to Europe by Isaak Thyssen, head of Dutch trading station near Nagasaki

## 1853

Commodore Matthew Perry officially received by the Japanese. On March 31, 1854, two Japanese ports opened to trade with the West. Commercial treaties concluded with France, Great Britain, Russia, and United States in 1855 and with Netherlands in 1856

## 1856

Félix Bracquemond, French etcher, discovers Hokusai's *Manga* (*Sketches*) at shop of his printer, Delâtre

## 1860

French edition of Laurence Oliphant's *Narrative of the Earl of Elgin's Mission to China and Japan* (first published London, 1859) includes reproductions of prints by Toyokuni II, Hiroshige I, and Hiroshige II

## 1861

Le Baron Ch. de Chassiron's *Notes sur le Japon, la Chine, et l'Inde, 1858–1860* is first French book to reproduce facsimile designs from *Manga* and other works by Hokusai

June 8: Japanese prints mentioned for first time in *Journals* of Edmond and Jules de Goncourt

Charles Baudelaire writes in a letter: "Quite a while ago I received a packet of *japonneries*. I've split them up among my friends.. ."

## 1862

London International Exhibition: first systematic display of Japanese art in Europe, includes Japanese books and prints from collection of Sir Rutherford Alcock

Boutique de Soye (La Porte Chinoise), Japanese import shop, opens at 220 rue de Rivoli, becomes mecca for *japonistes*

## 1863

James McNeill Whistler discovers Japanese prints in London, soon becomes most active emissary of *japonisme* between France and England

The Goncourts acquire album of Japanese erotic woodcuts

## 1864

Rodolphe Lindau's *Voyage autour du Japon* published

J.-F. Millet and Théodore Rousseau collect Japanese prints

Whistler paints his friend Jo in kimono looking at Japanese prints

## 1866

The Goncourts publish *Manette Salomon*, a novel, and devote a chapter to oriental daydreams of the hero exploring Japanese woodcut albums

## 1867

In Japan the young emperor overthrows shōgun; increased interest in trade follows and contacts with West multiply

Paris Universal Exposition: elaborate Japanese exhibition spreads awareness of Japan among Parisian artists; one hundred Japanese prints are shown and later sold

Paris Japanophiles found the Club Jinglar; Bracquemond designs tableware, "Le Service Japonais," after plant and animal designs of Hokusai and Hiroshige

February–March: Zacharie Astruc writes series, "L'Empire du Soleil Levant" for the newspaper *L'Étendard*

## 1868

Manet paints Zola's portrait, in which Japanese print is shown beside sketch for his painting "Olympia"

## 1869

Ernest Chesneau publishes pamphlet *L'Art Japonais*

## 1870

Monet discovers Japanese prints in Holland

## 1872

In his book *L'Art Francais en 1872* Jules Claretie dubs cult of Japan "japonisme"

Philippe Burty cites "japonisme" in a series on Japan for *La Renaissance littéraire et artistique*

## 1873

Major exhibition of art from Japan, China, India, and Java (most pieces collected by Henri Cernuschi and Théodore Duret during 1871–73 voyage to the East) at Palais de l'Industrie

## 1876

Monet paints his wife, Camille, in kimono and calls portrait La Japonaise

## 1878

Paris Universal Exposition: Japanese pavilion exhibits ceramics, lacquers, and print albums and is reviewed by Edmond Duranty: "L'Extrême Orient à l'Exposition Universelle," *Gazette des Beaux-Arts,* December 1878

Chesneau publishes "Le Japon à Paris," *Gazette des Beaux-Arts,* September 1878, first important article on influence of Japanese art on major French artists

## 1880

Émile Guimet publishes *Promenades Japonaises*

## 1882

Duret publishes pamphlet *L'Art Japonais* and traces history of Japanese woodcut in essays on Hokusai in *Gazette des Beaux-Arts,* August and October 1882

## 1883

Louis Gonse (director of *Gazette des Beaux-Arts*) publishes *L'Art Japonais* in two lavish volumes, the first systematic history of oriental art in the West

Georges Petit Galleries exhibit 3000 pieces of Japanese art, including prints, from private Paris collections. Exhibition organized by Gonse and Japanese print expert Tadamasa Hayashi

Monet moves to Giverny, decorates house with Japanese prints, installs Japanese garden

## 1885

S. Bing, German art dealer, opens Paris shop at 22 rue de Provence, is host to monthly meetings of *japonistes*

## 1887

Theo and Vincent van Gogh organize exhibition of Japanese woodcuts at the café Le Tambourin. The event is recorded in van Gogh's painting La Femme au Tambourin; he also paints copy of Hiroshige's woodcut Ōhashi (bridge) in Rain and Portrait of Père Tanguy with Japanese Prints

Burty publishes only issue of planned periodical, *Le Japon Artiste*

## 1888

May: Exhibition of Japanese prints at Bing's shop. Bing publishes first issue of monthly periodical *Le Japon Artistique*, which runs until 1891

The Nabis meet regularly and discuss Japanese prints

Pierre Loti publishes popular novel *Madame Chrysanthème*, an account of a sailor's stay in Japan

## 1889

Paris Universal Exposition: Sada Yakko, "The Great Actress of Japan," and her troupe are popular attraction

Paul Gauguin paints Still Life with Head-shaped Vase and Japanese Woodcut

## 1890

April 25–May 22: Exhibition of Japanese woodcuts at the École des Beaux-Arts. Catalogue includes 1153 entries for prints, albums, and illustrated books

## 1891

Edmond de Goncourt publishes *Outamaro, Le Peintre des Maisons Vertes*, first volume in his intended series on Japanese art history

Mary Cassatt completes set of ten color aquatints in imitation of Japanese woodcuts

March: Exhibition and sale of Burty's collection at Bing's shop

## 1892

Toulouse-Lautrec designs poster for oriental-style café Le Divan Japonais and draws scene from spectacular Japanese ballet *Papa Chrysanthème* staged at Nouveau Cirque

## 1893

Bing organizes exhibition of more than 300 prints by Hiroshige and Utamaro at Durand-Ruel Galleries

## 1896

Edmond de Goncourt publishes *Hokousai* volume of his intended Japanese art series

## 1897

March: Sale of Goncourt collection of Japanese and Chinese art. Catalogue, with preface by Bing, lists 1637 items

## 1899

Ambroise Vollard publishes Bonnard's *Aspects of Parisian Life* and Vuillard's *Landscapes and Interiors*, color-lithograph portfolios influenced by Japanese woodcuts

## 1900

Paris Universal Exposition: critically ill Toulouse-Lautrec is cheered by Sada Yakko's performance in Loie Fuller pavilion

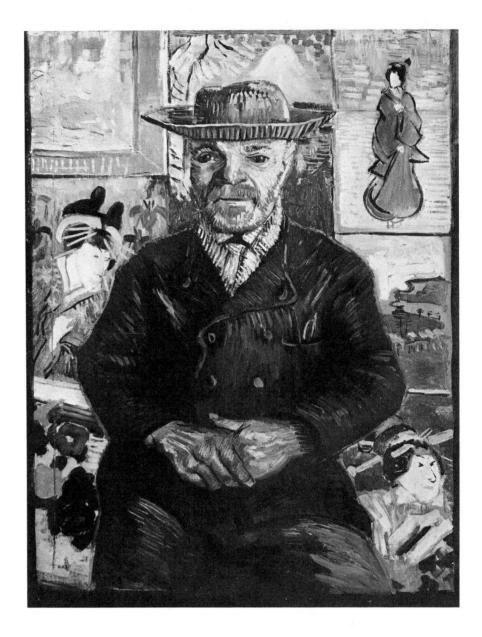

2 VINCENT VAN GOGH, 1853–1890

*Portrait of Père Tanguy with Japanese Prints. Oil on canvas. 1887–88*

Stavros S. Niarchos Collection

# Impressionism
# and Ukiyo-e

Before Commodore Matthew Perry reopened commerce with Japan in 1854, Japanese art in Europe was rare indeed. The Japanese ports had been sealed for two centuries by the political exclusivism of the Tokugawa government, until commercial agreements reached in 1855 brought the first wave of Japanese artifacts to European shores. The shōgunate fell in 1867, and, in the international spirit that ensued, Japan took a pavilion at the Paris Universal Exposition the same year. There Parisians saw their first formal exhibition of Japanese art, which, in the years that followed, poured into France.

Enthusiasts of the century-old rococo style with its borrowed "chinoiseries" were among the first Frenchmen to be serious about Japanese art (which was at first mistaken for Chinese). Decorative bronzes, porcelains, and lacquered goods, which found a market through the China trade, were the first popular imports from Japan. Woodcut prints gathered their following more slowly, and even late in the century they remained the special province of the avant-garde.

One of the ironies of art history is that the woodcuts, just as they were beginning to arouse the interest of artists and art lovers in the West, had crested and begun the decline of their own stylistic development. In fact the "decadent" late prints circulated first and farthest in France. The Japanese artists who officially represented their country at the Universal Exposition were the leading print designers of the day (Kuniteru, Sadahide, Hiroshige III, Kunisada II, etc.), but they were also the last and weakest generation of their school. The one hundred prints that revealed Japanese life to the Parisians were sold after the close of the Exposition and in themselves formed one swell in the wave of *japonisme*.[1] Since they were readily available—virtually fresh off the woodblock—the late cuts continued to arrive in Paris in numbers, spreading the Japanese message from import shops and collectors' albums. Their dispersion is reported in paintings by Manet, Monet, Gauguin, and van Gogh (*2*), who insisted, "Whatever one says, even the most vulgar Japanese sheets colored in flat tones are, for the same reason, as admirable as Rubens and Veronese."[2]

The first meeting of French art and the Japa-

nese print is placed at about 1856, when the etcher Félix Bracquemond came upon a volume of Hokusai's *Manga* (*Sketches*) (*3*) at the shop of Delâtre, his printer. Delâtre, who had discovered the book used as packing material in a shipment of porcelain, would not part with it. After a year Bracquemond contrived to buy a copy from the printmaker Eugène Lavieille and shared his treasure with his friends Philippe Burty (*4*), Zacharie Astruc, and Manet. A decade later, still a standard-bearer for things Japanese, Bracquemond designed a complete set of tableware based on motives from Hokusai and Hiroshige.[3] This *Service Japonais* was probably meant for use at the dinner meetings of the Club Jinglar, at which kimonos and chopsticks supplanted frockcoats and flatware.[4]

By 1868 Japanese prints were well enough admired and circulated that the Goncourt brothers, Jules and Edmond, forever flaunting their connoisseurship, recorded the phenomenon, however subjectively:

> *The taste for things Chinese and Japanese! We were among the first to have this taste. It is now spreading to everything and everyone, even to idiots and middle-class women. Who has cultivated it, felt it, preached it, and converted others to it more than we; who was excited by the first Japanese prints and had the courage to buy them?*[5]

There is little doubt that the Goncourts were among the earliest and most devoted collectors of Japanese art. The sale of their collection in 1897 included, among more than 1500 Japanese items, 372 prints and illustrated books. (At one point Edmond de Goncourt confessed to carrying away from the dealer Bing "enough Japanese prints to load a horse.")[6] The Goncourts' *Journals* are full of references to Japanese art, and in their novel *Manette Salomon* (1866) an entire chapter is devoted to one of the earliest, longest, and most lovingly picturesque encounters with *japonisme* in all French fiction: the hero is lounging in his apartment, its floor strewn with Japanese albums. Forgetting the gray Paris day outside his window,

3 KATSUSHIKA HOKUSAI, 1760–1849

*A magician turning paper into cranes. Page from the* Manga (Sketches), *vol. 10. 1819*

The Metropolitan Museum of Art. Rogers Fund, 1931. Japanese illustrated book no. 81.10

4 FÉLIX BRACQUEMOND, 1833–1914

*Frontispiece for the catalogue of Philippe Burty's print collection, vol. 2. Etching. 1878*

The Metropolitan Museum of Art. Gift of Mrs. Katherine Ticknor Heintzelman, 66.709.15

5 HENRI SOMM, 1844–1907

*Japonisme. Etching. 1881*

The Metropolitan Museum of Art. Bequest of Harry G. Friedman, 67.539.201

he is transported by "crimson sunsets," "white beaches, teeming with crabs," and "women gliding along in river boats, leaning nonchalantly over fleeting and poetic waters" (pp. 245–50).

It is not known when the impressionists and their set discovered the refined and seductive charms of the eighteenth- and early-nineteenth-century Japanese woodcut prints, which were necessarily in shorter supply than the contemporary offerings. However, in 1883, when Louis Gonse published his landmark two-volume *L'Art Japonais,* he reserved special praise for Utamaro, Harunobu, and Kiyonaga. Of Hokusai, the undisputed master, Gonse said: "The complete works of Hokusai would be the glory of any print collection and could be placed beside those of Rembrandt…" (II, pp. 354–55). Hokusai's captivating *Manga* remained a treasure-house for practically every artist from Manet to Gauguin. Philippe Burty, critic and collector, acclaimed Hokusai's sketches for "rivaling Watteau in their grace, Daumier in their energy, the fantastic terror of Goya and the spirited animation of Delacroix." Only Hiroshige, whom Pissarro called

"a marvelous impressionist," and Utamaro, whose graceful courtesans, bathers, and mothers with mischievous children enchanted French draughtsmen, challenged Hokusai's reputation.

It is said that Whistler discovered Japanese prints in a Chinese tearoom near London Bridge and that Monet first came upon them in a spice shop in Holland where they were used as wrapping paper. In the 1850s and early 60s it was still possible to find bargain prints this way. But a general appreciation for Japanese things soon spread through literary and artistic circles, making oriental import shops like Mme de Soye's La Porte Chinoise a rendezvous for eager collectors: the Goncourts, Manet, Whistler, Tissot, Fantin-Latour, Baudelaire, Théodore Duret, and Burty.[7] Soon after Duret and Henri Cernuschi returned from a tour of the Orient (1871–73) laden with art, *japonisme* (5) hit its stride. Collections of bronzes, ceramics, lacquers, ivories, and prints appeared in Paris studios and drawing rooms. In the mid-80s the interest in Japanese woodcuts stimulated a lively trade led in Paris by the expert Tadamasa Hayashi and the dealer S. Bing, whose attic and

6 UTAGAWA TOYOKUNI,
1768–1825

*Four seasons in the south;
a summer view. Color
woodcut; two sheets of a
triptych*

The Metropolitan Museum of
Art. The H. O. Havemeyer
Collection. Bequest of Mrs.
H. O. Havemeyer, 1929. no.
1747

cellar print caches were visited by Bonnard, van Gogh, Gauguin, and Toulouse-Lautrec.[8] In response to the prints' popularity art galleries mounted major shows, climaxing with the 1890 exhibition at the École des Beaux-Arts, which included more than a thousand prints and illustrated books from private collections.

As Japanese art passed from a fashionable mania to the realm of the expert and scholar, collectors became connoisseurs. Toward the end of the century they concentrated on only the specimens of native Japanese art that were new to the West. Fine examples of early woodcuts became so scarce that in 1893 a writer for *Figaro Illustré* lamented: "Right now, in order to find a beautiful impression . . . it takes innumerable searches, negotiations and trips to places where a foreigner is incapable of dealing with the slow, diplomatic procedures he must follow—and where bribing does no good."[9]

Japan's role in the development of nineteenth-century decorative arts can be compared to China's molding of rococo. A source of exotic motives and a stimulus to lighter, organic designs, Japanese ornament spawned the serpentine style called art nouveau. The popularity of Japanese bric-a-brac, fans, parasols, combs, and textiles encouraged manufactured imitations, some dreadful—others sublime. (The jewelry, glass, and ceramics of Lalique, Gallé, and Chapelet were superior Gallic adaptations.)

The influence of the Japanese color woodcut was felt on an entirely different level: The Paris studios of two generations of unknown painters were scattered with the bright, flat woodcuts of the Edo school that were to change the course of western pictorial art. Manet, Degas, Gauguin, and the Nabis, who rebelled against the pomp and decadence of the French Academy, could hardly have realized that the Japanese printmakers they admired most had fought the same oppression two hundred years before. A rapid growth of a prosperous city population in seventeenth- and eighteenth-century Edo (Tokyo) had

14

given rise to a new democratic trend in art. Moronobu, Torii Kiyonobu, and their followers rejected stale subjects and rigid canons and founded a popular, vital sensibility they called *Ukiyo,* "the floating world," in which the central doctrines were "... the pleasures of the moon, the snow, the cherry blossoms and the maple-leaves, singing songs, drinking wine ... and floating...."[10]

In practice Ukiyo became the world of entertainment and daily pastimes: the theater and the café, picnics and boating parties, busy streets and private households—a celebration of ordinary scenes and events *(6, 7).* Ukiyo-e prints were popular and cheap; sold on city streets, they were the posters, the billboards, and the picture postcards of their day. Their casually treated views of contemporary life could hardly have been closer to impressionist aims.

7 JAMES (JACQUES JOSEPH) TISSOT, 1836–1902

*In Foreign Climes. Etching from the series* The Prodigal Son. *1881*

The Metropolitan Museum of Art. Elisha Whittelsey Fund, 68.539.201

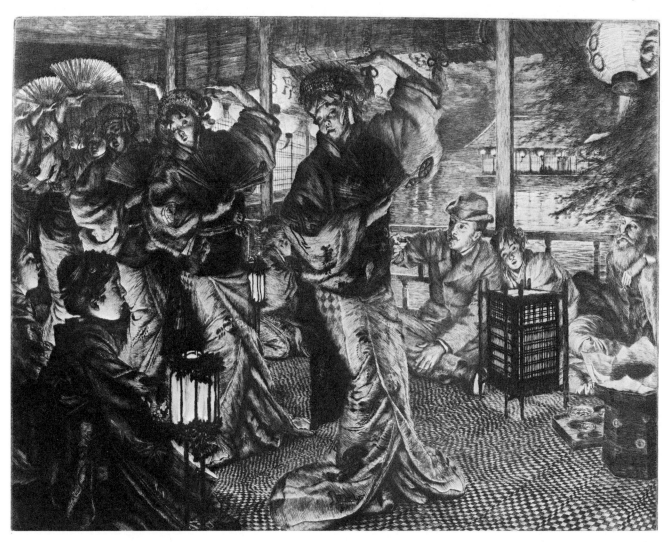

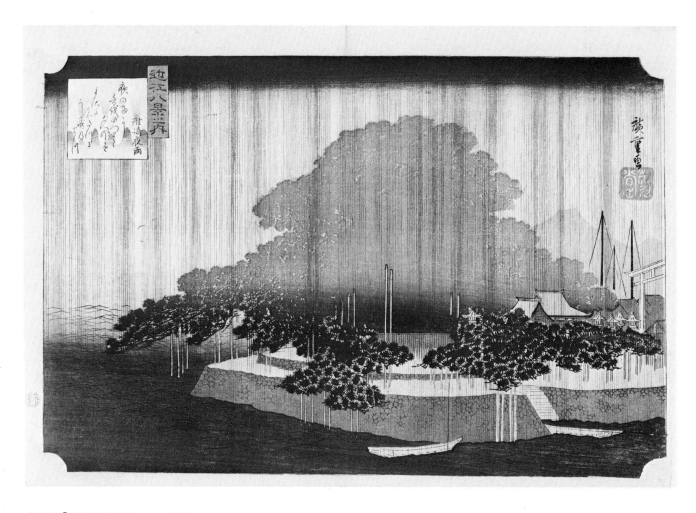

8 ANDŌ HIROSHIGE, 1791–1858

*Evening rain at Karasaki, pine tree. Color woodcut from the series* Eight Views of Lake Biwa. *1830*

The Metropolitan Museum of Art. Ex. coll. Howard Mansfield. Rogers Fund, 1936. no. 2476

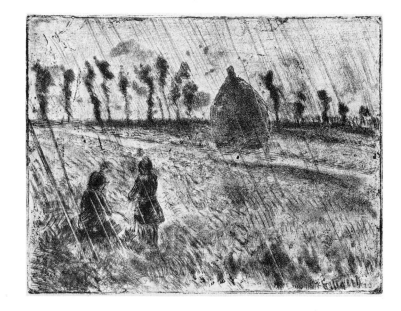

9 CAMILLE PISSARRO, 1830–1903

*Rain Effects. Aquatint and drypoint, sixth state. 1897*

Prints Division, New York Public Library, Samuel P. Avery Collection

But the democratic realism of the Ukiyo-e was far from the single attraction they held for the nineteenth-century French. The press of impressionist art toward emphasis on the picture surface was reinforced by the Japanese prints' blatant flatness. Manet, the "father" to impressionism, was the first major painter to respond to Ukiyo-e's altered vision. The peculiar flatness and static quality in his work can be attributed to the pure colors and unmodeled shapes that typify Japanese prints. Degas trained his eye on the unstudied poses and novel perspective of the Japanese. His insistently patterned wallpapers, rugs, and upholstery are the impressionist counterparts of the decorative fabrics whose rhythms recur in Ukiyo-e designs.

Other aspects of Ukiyo-e drew their French admirers as well. The Japanese genius for conveying the seasonal changes and the fugitive effects of weather, wind, and water—the whirlpool, the wave, the falling rain (8, 9)—endeared Ukiyo-e to impressionist landscapists. Whistler, one of the first collectors of Far Eastern treasures, embraced the essence of the Japanese picturesque in his chic, perfectly placed butterfly cachet (10).[11] "These Japanese confirm my belief in our vision," wrote Pissarro.[12] The journalists and critics of the 80s, who, by no accident, were Japanese art enthusiasts themselves, concurred. The most vocal homage to the East came from Émile Zola, Burty, and Duret, who declared the Ukiyo-e artists "the first and most perfect of the Impressionists."[13]

Late in the century, when the Nabis deemed all art essentially decoration, the very Ukiyo-e-inspired patterns that had hovered at the edges of Degas's prints became the most prominent elements in the lithographs of Bonnard and Vuillard. Elsewhere Japanese prints empowered Gauguin and Toulouse-Lautrec with a new graphic abstraction based on simple forms, a few principal planes, and a focus on line. The expressionists (and Odilon Redon as well) recognized the potency of oriental art's frank distortions.

At the close of the century, the French artists produced the prints that came nearest to their

10 JAMES ABBOTT McNEILL WHISTLER, 1834–1903

*Tall Bridge. Lithograph. 1878*

The Metropolitan Museum of Art. Harris Brisbane Dick Fund, 17.3.161

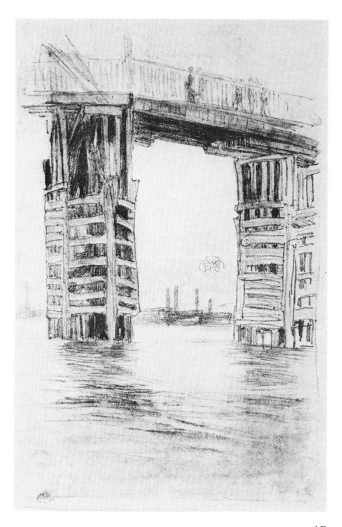

13 (OPPOSITE PAGE) AUGUSTE LEPÈRE, 1849–1918

*Convalescente, Mme Lepère. Color woodcut. 1892*

The Metropolitan Museum of Art. Anne and Carl Stern Fund,
1970.532

Japanese models—in both design and technique.
Almost simultaneously Félix Vallotton (*11*),
Émile Bernard, and Gauguin reverted to the
oldest oriental process of printmaking and began
cutting woodblocks. Henri Rivière and Auguste
Lepère (*13*) experimented with Japan's refined
and erudite process of color-washed woodcuts
(*12*). Mary Cassatt, in a series of color etchings
that combined aquatint and drypoint, recreated
the look of Ukiyo-e and applied it to the parlors
and nurseries of Paris.

11 FÉLIX VALLOTTON, 1865–1925

*Fireworks. Woodcut. 1901*

The Metropolitan Museum of Art. Rogers Fund, 19.63.5

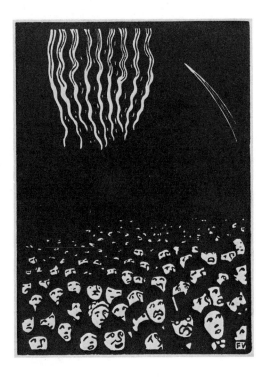

12 EISHŌSAI CHŌKI

*Girl and the sunrise over the sea at New Year's. Color
woodcut. About 1794*

Victoria and Albert Museum, London. Bequeathed by Marmaduke
Langdale Horn

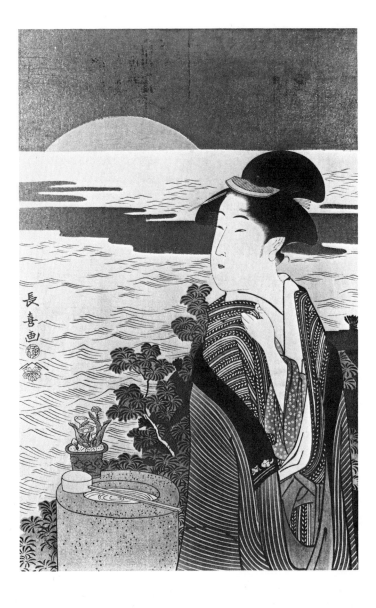

18

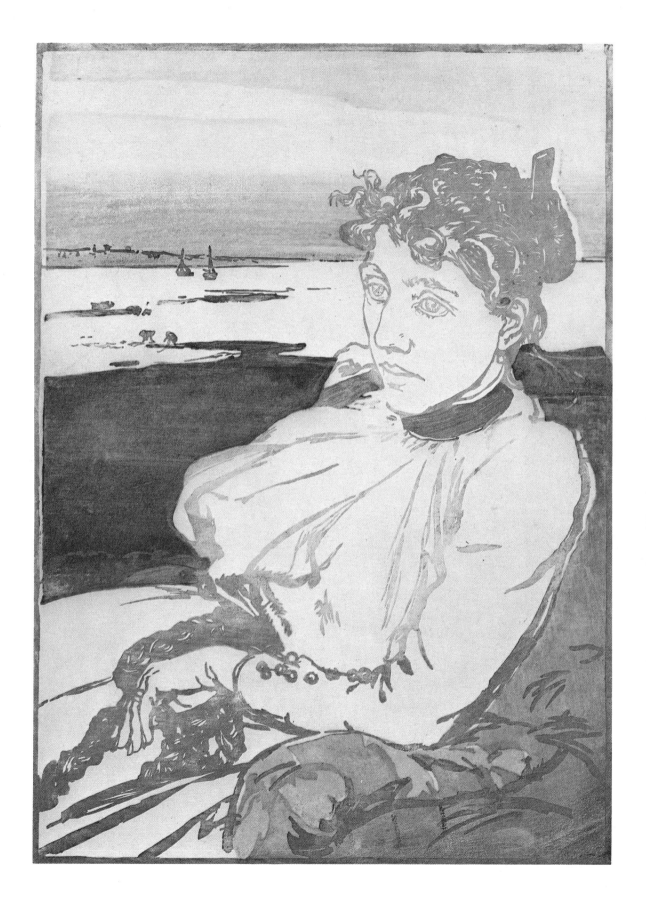

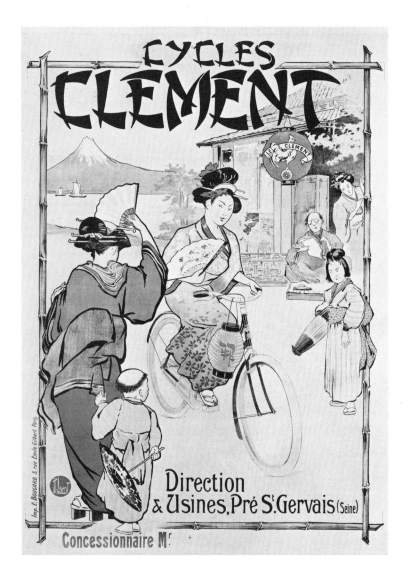

14 *Poster for Clement bicycles. Color lithograph. About 1900*

Courtesy of Lords Gallery, London

15 HENRI JOSSOT

*The Wave (a spoof on Hokusai's Great Wave and the impact of Japanese influence in France) Color lithograph published in* L'Estampe Originale, *1894*

The Metropolitan Museum of Art. Rogers Fund, 22.82.1-5

The popularization of Japanese prints created a demand for color images that sparked technical innovations in color lithography. The successive publication of the color print portfolios *L'Estampe Originale* (1893–95) and Ambroise Vollard's *Album des Peintres-Graveurs* (1896–97) encouraged excursions into the lithographic medium. The Japanese woodblock print was the deter-

mining influence on the French age of the poster—the 1880s and 90s (*14*). The poster's stress on line and its broad unmodeled forms imposed maximum readability on advertising design.

Virtually every major artist at work in late-nineteenth-century France benefited from contact with Japanese prints. Our very idea of French impressionism and postimpressionism as move-

20

ments that freed the artist's imagination and glorified his mundane subjects reveals the deep kinship between the French printmakers of the 1800s and the Ukiyo-e printmakers, who had struggled toward the same ends a century earlier. The natural affinity between them was obvious even in 1878, when Ernest Chesneau said of Manet, Monet, and Degas: "All found a confirmation rather than inspiration for their personal ways of seeing, feeling, understanding and interpreting nature. The result was a redoubling of individual originality instead of a cowardly submission to Japanese art." [14]

The Japanese impact (*15*) reverberated far beyond the borders of France, reaching London, Vienna, Glasgow, Boston, and New York. That the French took the most from their association with the East is perhaps because the meeting was so utterly timely: the impressionists were struggling toward a social and esthetic reordering, and in the fullblown abstraction of the Ukiyo-e woodcuts they saw the revolution accomplished.

1. This information comes from published records preserved in the official archives of the National Library, Tokyo. See Terukazu Akiyama, *Japanese Painting* (Geneva [?], 1961), p. 180. I am indebted to Columbia University student Margaret Clay for bringing this source to my notice.

2. Letter no. 542 of van Gogh, whose devotion to Japanese prints exceeded that of any other artist of the period, even prompting him to paint copies of three woodcuts by Keisai Eisen and Hiroshige. See M. E. Tralbout, "Van Gogh's japanisme," *Mededelingen van de Dienst voor Schoene Kunsten der Gemeente 's-Gravenhage*, nos. 1–2, 1954; Jay Martin Kloner, "Van Gogh and Oriental Art, unpublished M.A. thesis (New York: Columbia University, 1963).

3. Bracquemond meanwhile produced numerous etchings of birds and fish after Japanese models. See Gabriel P. Weisberg, "Félix Bracquemond and Japanese Influence in Ceramic Decoration," *Art Bulletin*, vol. 51 (September 1969), pp. 277–80.

4. Members of the "Société Japonaise du Jinglar" included Bracquemond, Philippe Burty, Zacharie Astruc, Alphonse Hirsch, Jules Jacquemart, Carolus-Duran, Fantin-Latour, and Solon. Jinglar was a sweet, exotic-tasting wine served at their dinner meetings.

5. Goncourt, *Journals*, October 29, 1868. A more accurate account of early *japonisme* is John Sandberg's article, "The Discovery of Japanese Prints in the Nineteenth Century, Before 1867," *Gazette des Beaux-Arts*, vol. 71 (May 1968), pp. 295–302.

6. *Ibid.*, April 4, 1891. The prints were taken to the expert Hayashi for interpretation and later returned to Bing, who apparently gave them "on approval."

7. Mme de Soye and her husband had lived for a time in the Orient. Her shop, sometimes referred to as the "Boutique de Soye," may have opened in 1862, although there is evidence that La Porte Chinoise existed in the 1830s.

8. There were numerous dealers and shops with oriental goods opening between 1870–1900. Among those for which trade cards still exist in the Musée des Arts Décoratifs, Paris, and The Metropolitan Museum of Art, New York, are: Margelidon, "curiosités japonaises"; Sichel, 80 rue Taitbout; Oppenheimer Frères, 21 rue de Cléry; Au Mikado, 7 rue le Bastard; Dépôt des Produits du Japon, 49 rue de la Victoire.

9. C. D. (Carolus-Duran?), "Japonisme d'Art," *Figaro Illustré*, April 1893.

10. "Ukiyo," originally a Buddhist word for "the transient world," had gloomy connotations until it was redefined in more pleasurable terms about 1661 in the *Ukiyo Monogatari*, quoted by D. B. Waterhouse, *Harunobu and His Age; The Development of Color Printing in Japan* (London, 1964), p. 14.

11. See John Sandberg, "*Japonisme* and Whistler," *The Burlington Magazine*, CVI, 1964, pp. 500–507.

12. Camille Pissarro's letter to his son, Lucien, is dated 1893.

13. Théodore Duret, *Critique d'Avant Garde* (Paris, 1885), p. 165.

14. Ernest Chesneau, "Le Japon à Paris," *Gazette des Beaux-Arts*, September 1878, pp. 385–97.

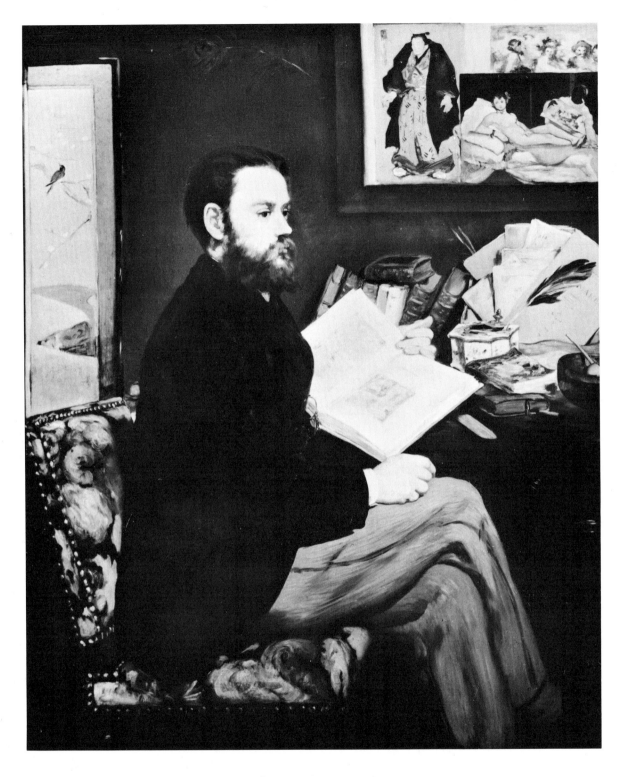

16 EDOUARD MANET, 1832–1883.  *Portrait of Émile Zola. Oil on canvas. 1868*

Musée du Louvre, Paris (Gift of Mme Zola)

# Edouard Manet

**F**ew painters have used prints by other artists more frequently or to greater advantage than Manet. A print collector of wide-ranging tastes and a regular visitor to the Cabinet des Estampes of the Bibliothèque Nationale, Manet pored over scrapbooks of Old Master engravings, admired prints of Raphael, Velasquez, Le Nain, and Goya and copied portions of them in his own compositions. His most famous appropriation is the group of three figures from Marcantonio Raimondi's engraving of Raphael's Judgment of Paris, which Manet placed in the foreground of his painting The Luncheon on the Grass. His talent for selecting and recombining such details, and conceiving them as new images, led Manet to Dutch, Spanish, French, and Italian works, and further still, to oriental art.

It is not surprising that Manet, who answered Baudelaire's call for a painter of "la vie moderne," was drawn to Japanese popular prints. Like Ukiyo-e artists, he was eager to shun history in order to focus on the here and now, the "floating world" of Parisian daily life. Besides discovering Japanese prints to be the magic containers of real life, Manet also found they supported the flat and abstract tendencies in his own art.

Ernest Chesneau listed Manet among the artists and writers who were the earliest collectors of Japanese art.[1] Several of Manet's closest friends were also on the list, among them Zacharie Astruc, Philippe Burty, and Théodore Duret, all early champions of impressionism and Japanese art.[2]

Manet painted Astruc's portrait in 1864 and included in the picture a Japanese fiber-bound book as testimony to their shared admiration for Japanese art. Duret, with whom Manet browsed through La Porte Chinoise, the oriental shop on the rue de Rivoli, became Manet's portrait subject in 1868, and after Duret returned from a trip to Japan,[3] Manet painted the little Japanese dog, Tama, he had brought back with him.

The portrait of another fellow *japoniste*, Émile Zola (*16*), is generally considered a high point of Japanese influence in Manet's work. The 1868 painting shows Zola seated before a Japanese folding screen and a framed grouping of three pictures that includes a study of Manet's painting "Olympia" and two prints: Goya's etching of Velasquez's Los Borrachos and a woodcut of a wrestler by a little-known Japanese artist, Kuniaki II.[4] The two prints represent diverse artistic influences which, as Zola himself had earlier noted, were synthesized in Manet's notorious "Olympia."

Zola had been the first critic on record to link Manet's art to Japanese prints when, in 1866, he defended Manet's style against a torrent of public criticism. Countering the popular comparisons of Manet's paintings to the vulgar, crudely colored sheets printed at Épinal, Zola suggested that "it would be much more interesting to compare this simplified style of painting with Japanese prints which resemble Manet's work in their strange elegance and splendid color patches."[5]

After 1859 Manet's devotion to Spanish painting and his developing fascination with Japanese art led him toward compositions built up of two-dimensional planes and broad distributions

of dark and light. Soon he began to include exotic trappings as well: during the 1860s guitars and mantillas figured in his paintings; in the later 60s and 70s a Japanese fan, an Ukiyo-e woodcut, or a folding screen occasionally appeared. Valéry said that such colorful souvenirs were prompted by Manet's "fondness for the picturesquely exotic." But Manet went far beyond the mere copying of curios to penetrate the essence of a foreign art.

Manet's "Olympia" is so redolent with *parfum japonais* that she might have been a geisha in an Ukiyo-e print. Proper Parisians were scandalized by this regally titled prostitute and were just as indignant over the irreverent black cat at her feet. Compared to the traditional pet of western art, who basks in the dignity of the goddess it attends, this cat is a tramp—and intentionally so. Manet must surely have found the creature's prototype among the witty observations of animal life that run through Japanese art.

Perhaps Manet meant to capitalize on the notoriety of the black cat when, in 1868, he de-

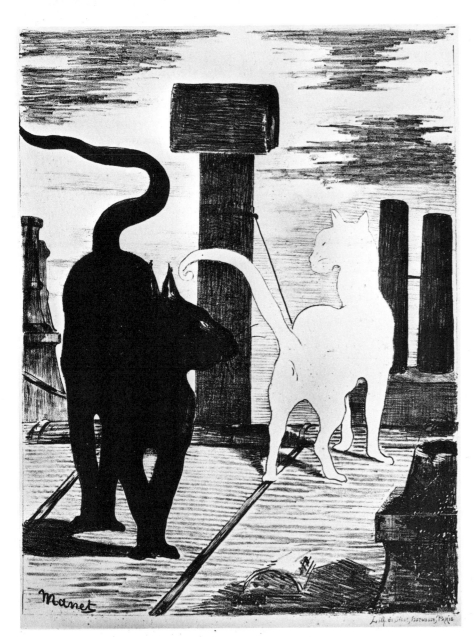

17 EDOUARD MANET

*The Cats' Rendezvous. Lithograph. 1868*

Prints Division. New York Public Library

18 UTAGAWA KUNIYOSHI, 1798–1861

*Cats in various attitudes. Color woodcut, fan print. About 1843–52*

The Raymond A. Bidwell Collection of Prints, Museum of Fine Arts, Springfield, Massachusetts

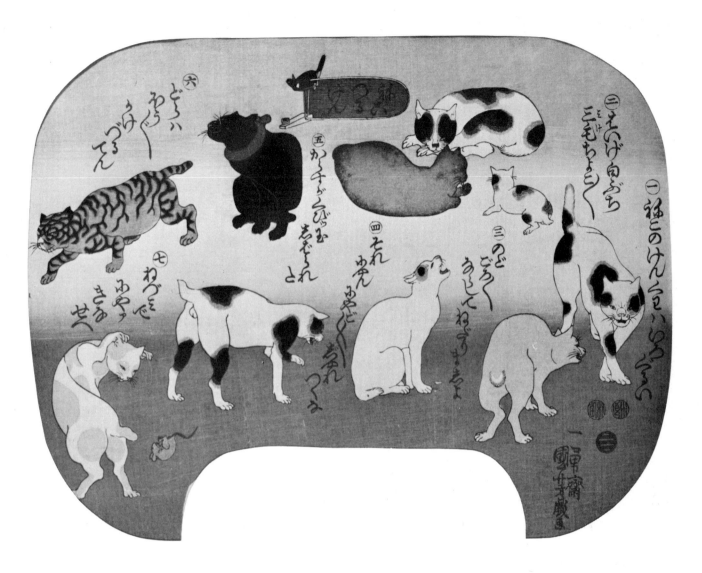

signed a lithograph of two equally whimsical felines as a poster to advertise Champfleury's charming book on cat lore, *Les Chats*. The Cats' Rendezvous (*17*), probably the first French poster of artistic note, owes its power to the Japanese print, both for its engaging subject and for the dramatic clarity of its design. It marks a peak of Japanese influence in Manet's graphic work, epitomizing his interpretation of Ukiyo-e as lighthearted in subject, bold in impact, and perfectly suited to the ephemeral arts of printmaking and book illustration.

Like so many Japanese prints, Manet's lithograph is composed of a succession of parallel planes; its flat shapes echo the silhouette style of Japanese woodcuts. The cats themselves, cleverly foreshortened and abstracted in sinuous contours, recall innumerable cats by the mid-nineteenth-century Japanese printmaker Utagawa Kuniyoshi. The supple and expressive cats in various attitudes in Kuniyoshi's fan design of about 1850 (*18*) are probably forerunners of Manet's caricatural types, who are set in similarly balletic poses. (Note particularly the two cats at the lower right of Kuniyoshi's woodcut.) Further evidence of Manet's familiarity with Kuniyoshi's work is provided in the painting Repose (1870–71), in which Manet copied Kuniyoshi's woodcut The Dragon King Pursuing the Ama with the Sacred Jewel.[6]

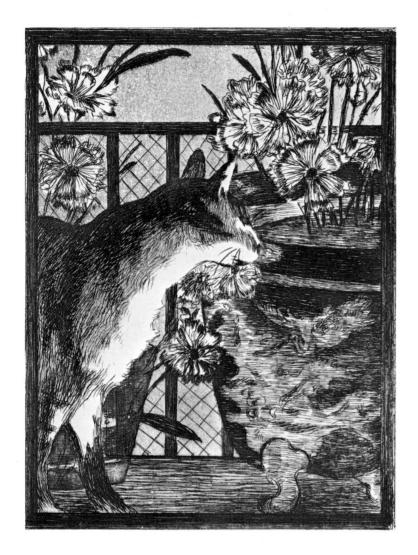

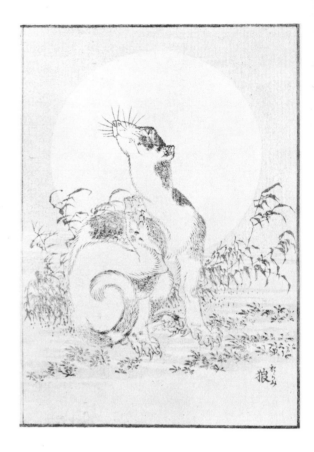

The 1870 edition of *Les Chats* included Manet's etching Cat and Flowers (*19*), which demonstrates his (and Champfleury's) abiding love for the Japanese way with cats. Champfleury had included several Japanese illustrations in his book, some of them by the Ukiyo-e master Hokusai, to whom Manet's own illustration bears a special debt.

Manet's cat, prowling about an oriental cache-pot filled with flowers, recalls two illustrations on facing pages in volume 14 of Hokusai's *Manga* (*Sketches*); one depicts a weasel seated in a clump of bamboo (*20*), the other, a mouse-catching cat (*21*). Hokusai's whimsical, white-throated weasel is in many ways a closer relative of the animal etched by Manet than is the other rather fero-

19 EDOUARD MANET

*Cat and Flowers. Etching and aquatint, third state. 1869*

The Metropolitan Museum of Art. Harris Brisbane Dick Fund, 28.93.1

20 KATSUSHIKA HOKUSAI, 1760–1849

*Weasel and bamboo. Woodcut illustration from the* Manga (Sketches), *vol. 14*

The Metropolitan Museum of Art. Rogers Fund, 1931. Japanese illustrated book no. 81.14

cious-looking hunter. But the framework in which Hokusai set his cat, a narrow space defined by vertical bands and smaller linear patterns, may easily have inspired Manet's composition. Similar textural qualities and a rhythmic distribution of black, white, and silvery gray mark both the Japanese and French illustrations.[7]

An etching of three cats, Les Chats (*22*), which Manet did the same year as his Cat and Flowers (1869), may also have been intended as an illustration for Champfleury's book. This random grouping of isolated images, all rendered in furlike hatches and with minimal modeling, suggests the pages of vigorous little animal sketches in Hokusai's books. Like Hokusai, Manet captured the vital characteristics of his subjects without an unnecessary line.

Hokusai's *Manga* is reputedly the first example of Japanese printmaking to be "discovered" by French artists. Félix Bracquemond came upon one of its fifteen volumes in 1856 and later showed it off to his friends and fellow artists, and probably to Manet, whom he met in 1861 and advised on printmaking techniques. Judging from

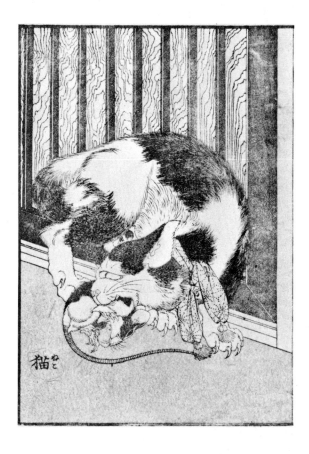

21 KATSUSHIKA HOKUSAI, 1760–1849

*Cat and mouse. Woodcut illustration from the* Manga (Sketches), *vol. 14*

The Metropolitan Museum of Art. Rogers Fund, 1931. Japanese illustrated book no. 81.14

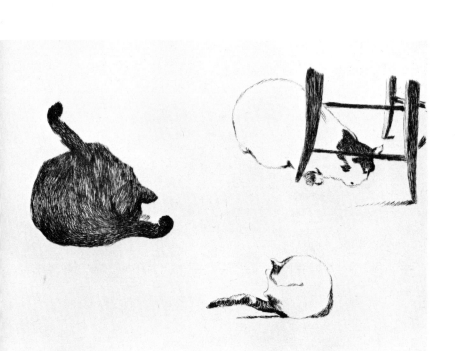

22 EDOUARD MANET

*Les Chats. Etching. 1869*

The Metropolitan Museum of Art. Rogers Fund, 21.76.26

Bracquemond's own etched copies of vignettes from Hokusai's sketchbooks, several volumes of the *Manga* were circulating by the mid-1860s. Manet himself may have owned a copy of volume 1, which supplied several motives he used in prints between 1870–76.

Manet adapted Hokusai's samurai in the rain (*23*) on leaf 15 of volume 1 to form the semiabstract mass of overlapping bodies and umbrellas that figures in his 1870 etching, Line in Front of the Butcher Shop (*24*). Though somewhat more realistically modeled, Manet's compact figural grouping is still schematic and relatively flat like Hokusai's image, the space almost as incompletely defined. Manet transferred Hokusai's linear patterns to his own print for surface interest

and fractured them under impressionism's bright light. Manet's composition emerges as a souvenir of Paris life under the 1870 Commune and has been regarded as a high point of his Japanism: "The miseries of war are pressed into a most poignant semi-abstract pattern, something between Goya and the Japanese print, yet very characteristically Manet."[8]

More than any other prints by Manet his eight small illustrations for Charles Cros's book *Le Fleuve* (*The River*), published in 1874, respect the spontaneity and economy of Hokusai. Manet's sketchy little renderings of seascape, landscape, dragonfly, and swallow (*25*) have the light touch of similar subjects in the *Manga,* volume 1. Manet must have been deeply impressed with

23 KATSUSHIKA HOKUSAI, 1760–1849

*Samurai in the rain. Woodcut illustration from the* Manga (Sketches), *vol. 1, 1812*

The Metropolitan Museum of Art. Rogers Fund, 1931. Japanese illustrated book no. 81.1

24 EDOUARD MANET

*Line in Front of the Butcher's Shop. Etching. 1870*

The Metropolitan Museum of Art. Rogers Fund, 21.76.28

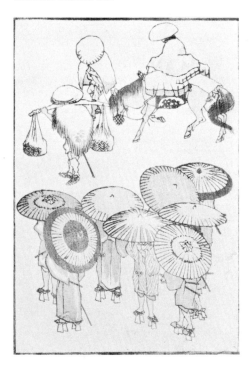

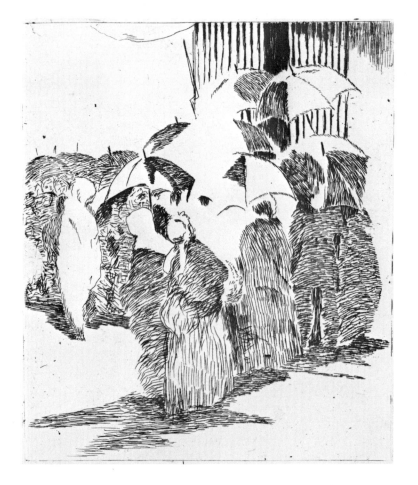

Qu'on se lise entre soi ce chant tranquille et fier,
dans les moments de fièvre et dans les jours d'épreuve;
qu'on endorme son cœur aux murmures du Fleuve.

Va, chanson! Mais que nul antiquaire pervers
n'ose jamais changer rien à tes deux cents vers!

25 EDOUARD MANET    *Illustrations in* Le Fleuve *by Charles Cros. Etching. 1874*

The Metropolitan Museum of Art. Harris Brisbane Dick Fund, 26.49.74

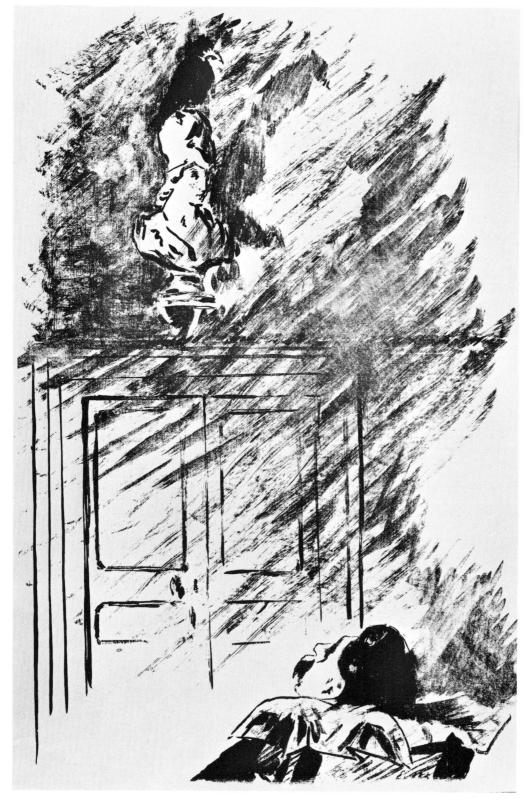

26 EDOUARD MANET

*The Raven on the Bust of Pallas.*
*Illustration for Edgar Allan*
*Poe's "The Raven." Transfer*
*lithograph. 1875*

The Metropolitan Museum of Art.
Harris Brisbane Dick Fund, 24.30.27

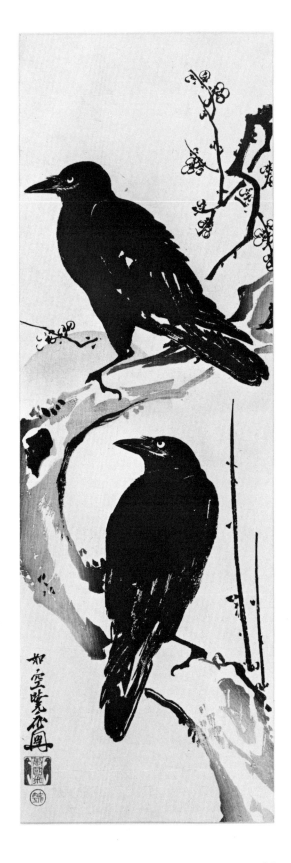

Hokusai's sharp vision and his clever draughts-
manship, apparently using the same methods to
achieve similar results. According to Théodore
Duret:

> [*Manet*] *always used to keep sheets of drawing
> paper ready to use in his studio, and a notebook
> and a pencil in his pocket. The slightest object
> or detail of an object which caught his interest
> was immediately noted down on paper....
> I know no one with whom he can be compared
> in this respect except Hokusai, whose rapid
> drawings of the* Manga *combine simplicity with
> perfect definition of character. Manet greatly
> admired what he had been able to see of
> Hokusai's work, and praised unreservedly the
> volumes of the* Manga *which he had come
> across. Indeed, like Hokusai, Manet conceived
> the purpose of drawing to be to seize the salient
> characteristics of a figure or an object, without
> any of its embarrassing accessories.*[9]

Manet leafed through the *Manga* again in 1876
and copied from it tiny bathers and scant foliage
to decorate Stéphane Mallarmé's poem "An
Afternoon of a Faun." His woodengraved motives
were complemented by the oriental-style binding
of the book's first edition, described by Mallarmé
as "one of those first costly pamphlets; a candy
bag, but made of dreams . . . somewhat oriental
with its Japanese felt, title in gold, and tie knots of
black and Chinese pink."[10]

The transfer lithographs for Mallarmé's
translation of Edgar Allan Poe's "The Raven"
(*26*) indicate that Manet had studied Japanese
brush drawing, which he could have seen repro-
duced in the woodcuts of the *Manga,* in drawings
belonging to Duret or Burty, or in prints such as
Kyōsai's crows (*27*). Manet, then, was one of
the first western artists to realize the power of
swift, sumi-brushed strokes. He drew his litho-
graphs for "The Raven" with black inkwash in the

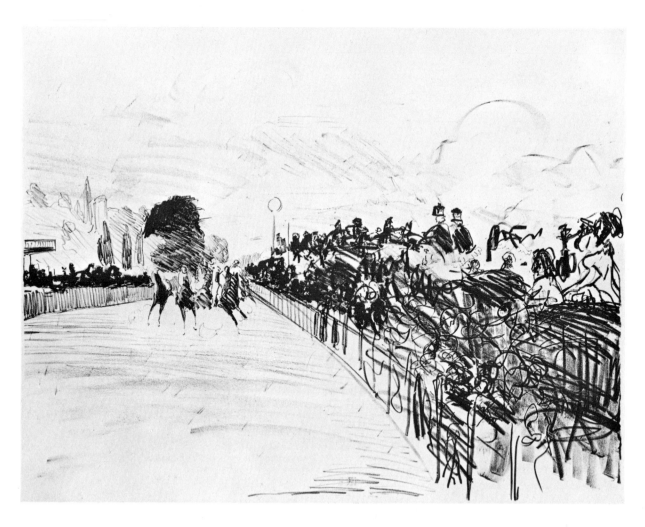

28 EDOUARD MANET

*The Races. Lithograph*

The Metropolitan Museum of Art. Rogers Fund,
20.17.2

29 ANDŌ HIROSHIGE, 1791–1858

*View of Akabane, Shiba District. Color
woodcut from the series* Famous Sights
of the Eastern Capital

The Metropolitan Museum of Art. Ex. coll.
Frank Lloyd Wright, Pulitzer Fund, 1918, no.
604

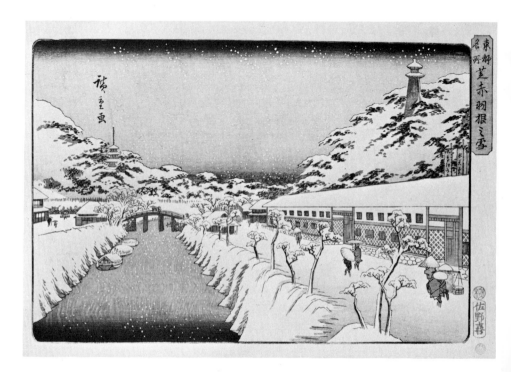

Japanese manner of fluid sweeps and daubs. Here, and in such startlingly modern-looking works as the lithograph The Races (*28*), Manet combined a potent, deceptively casual line with the spatial simplifications of Japanese art (*29*) and an oriental respect for the white of the page.

Spontaneity in the choice and treatment of subject matter marks many of Manet's works with outright Ukiyo-e influence. Having turned to Japan for new ways of seeing, Manet found — particularly in the anecdotal and casually treated prints of Hokusai — an answer, or at least a confirmation, of his own search for an art totally free of pomp. Though he was the first major nineteenth-century artist to be sympathetic with Ukiyo-e aims, Manet blended oriental ways with western means so successfully that he determined a major direction for art in the twentieth century.

As early as 1880 Huysmans complained that Manet had allowed himself to become too entranced by oriental art: "He showed the way to others, but he himself stayed in the same spot, in front of the Japanese prints. . . ."[11] It would seem, however, that Manet — neither overwhelmed nor mesmerized by the vogue — simply absorbed oriental flatness and boldness into his western point of view. The result was a highly personal fusion and an output extravagantly laced with diverse influences. The exact degree to which Manet's prints were stimulated by the Japanese is never clear; his formula for the mingling of styles in his work remains his secret and his genius.

1. Ernest Chesneau, "Le Japon à Paris," *Gazette des Beaux-Arts,* September 1878, p. 387.

2. Astruc was one of the first to publish essays on Japanese art with a series of articles on "The Empire of the Rising Sun" in *L'Étenard* in 1866; Duret wrote a brochure, *L'Art Japonaise,* in 1882; Burty started a publication, *Le Japon Artiste,* in 1887.

3. Duret, who already had a fine collection of Japanese objects, went to Japan with Henri Cernuschi in 1871 to buy what now constitutes a major part of the collection of the Musée Cernuschi.

4. Long thought to be a woodcut by Utamaro, the Japanese print was correctly identified as The Wrestler Ōnaruto Nadaemon of Awa Province (1860), the work of the minor nineteenth-century artist Kuniaki II. The identification was made by Ellen Phoebe Weise in her unpublished doctoral dissertation, "Source Problems in Manet's Early Paintings" (Cambridge, Mass.: Harvard University, 1959). The print may have belonged to either Zola or Manet, more likely Manet, since Zola sat for the portrait in the artist's studio.

5. The paintings that seemed so flat, objectionably unrealistic, and crudely colored to the French appeared quite otherwise to the Japanese. Louis Gonse learned this at the retrospective exhibition of Manet's work in 1884, which he reviewed in the *Gazette des Beaux-Arts* (February 1884, p. 134):

   *A Japanese friend, whose opinions we like to ask on matters of European art, avowed that he had been startled by the life-like appearance of these figures. "I imagined at first, that the people in the paintings had come to life, and were going to step out of the canvases to speak to me; a sensation," he added, "that I rarely experience in your paintings exhibitions." The play of lively colors surprised him less, his eye having been accustomed from infancy to receive a greater dose of light than ours. One knows that Japanese life is a life of open air. Shadow does not exist for the Japanese painter.*

6. This identification was made by Jay Martin Kloner in "The Influence of Japanese Prints on Edouard Manet and Paul Gauguin," unpublished doctoral dissertation (New York: Columbia University, 1968), p. 100.

7. Hokusai's illustrations may have had some influence on Manet's poster image for *Les Chats.* It is evident from the preparatory drawing that Manet first conceived his cats silhouetted by moonlight like Hokusai's weasel.

8. Ernst Scheyer, "Far Eastern Art and French Impressionism," *Art Quarterly,* VI, 1943, p. 125. Kloner (*op. cit.*) also suggests a comparison between this print and a similar configuration of grouped figures in plate 10 of Hokusai's *Manga* (volume 1), which shows pilgrims on their way to a shrine.

9. Théodore Duret, *Manet and the French Impressionists* (Philadelphia–London, 1910), p. 90. Duret wrote an essay on Hokusai for the *Gazette des Beaux-Arts* in 1882.

10. Kloner (*op. cit.*) notes Manet's borrowings from the *Manga* for these illustrations. The quote by Mallarmé is from G. Michaud, *Mallarmé,* trans. M. Collins and B. Humez (New York, 1965), p. 89, as noted by Jean Harris, *Edouard Manet, Graphic Works: A Definitive Catalogue Raisonné* (New York, 1970), p. 220.

11. Quoted in G. H. Hamilton, *Manet and His Critics* (New Haven–London, 1954), p. 238.

# Hilaire Germain Edgar Degas

Gaining entry to Degas's house was by no means easy, but one art lover named Jaeger devised a way: When he presented himself at Degas's door he was armed with two portfolios. "In one of them were a few drawings by Ingres ... and in the other a dozen of his best Japanese color-prints. The Ingres gave him the entrée into the living rooms in the rue Victor Massé, and the Japanese color-prints unlocked for him the doors of Degas's studio."[1]

Degas made no secret of his admiration for Japanese prints. He kept albums of them in a vitrine in his dining room; a diptych of bathers by Kiyonaga hung above his bed.[2] When his personal print collection was sold in 1918, it included over a hundred Japanese woodcuts and albums by Utamaro, Hokusai, Hiroshige, Kiyonaga, Toyokuni, and other Ukiyo-e masters.[3]

Unfortunately, there is little to document Degas's opinions of Japanese prints. In all his letters his single comment on the subject deplores the faddish state into which the cult of Japan had degenerated. Writing to his friend Bartholomé in April 1890, Degas declared the exhibition of Japanese prints that had just opened at the École des Beaux-Arts decidedly "old hat." In a metaphor linking hackneyed still-life paintings and oriental motives Degas dubbed *japonisme* "a fireman's helmet on a frog." "Alas, alas," he added, "this is the fad everywhere." A year later the critic George Moore assured his readers that Degas, unlike so many young artists who had succumbed to the temptations of "japonaiserie," disdained catering to the current fashion: "Degas thinks as little of Turkey carpets and Japanese screens as of newspaper applause."[4]

34

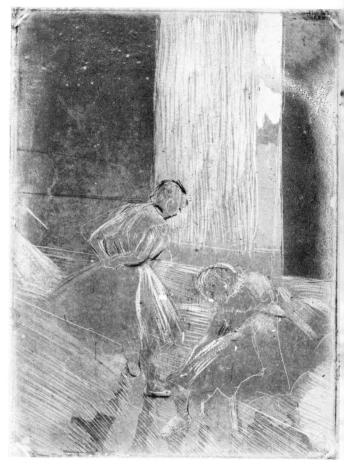

30 EDGAR DEGAS, 1834–1917

*The Two Dancers. Aquatint and drypoint. 1876–77*

The Metropolitan Museum of Art. Harris Brisbane Dick Fund, 25.73.1

Twenty-five years earlier Degas had been among the first artists to "discover" Japan. In 1865 he joined the group of painters, writers, critics, and collectors who met at the Café Guerbois and at Mme de Soye's oriental import shop, La Porte Chinoise. This company of Japanese art enthusiasts included Edmond and Jules de Goncourt, Philippe Burty, Émile Zola, Théodore Duret, Alexis Rouart, Baudelaire, Manet, Tissot, Whistler, and Bracquemond. If Degas himself did not have the most extensive oriental art collection, he always maintained relationships with those who did; he was on intimate terms with Manzi, whose Japanese prints helped to form the important Camondo Collection of the Louvre, and one

of his principal dealers, Portier, was a well-known Japanese print connoisseur. Opportunities to become acquainted with literally hundreds of Ukiyo-e woodcuts lay immediately at hand.

In about 1868 Degas painted a portrait of his friend James Tissot, in which an oriental-style garden scene hangs on the studio wall. The picture within the picture may allude to Tissot's Japan-inspired painting (later an etching), In Foreign Climes (7), from his *Prodigal Son* series.[5] Certainly the inclusion of the oriental piece acknowledged both painters' admiration for Japanese art.

It was not Degas's custom, however, to include Japanese objects, fans, kimonos, or other bibelots in his work, as so many of his contemporaries who were caught in the wave of *japonisme* did.[6] Without pointing directly to things Japanese, Degas nonetheless implied his respect for the newly imported art from the East and particularly for Japanese prints. They offered him a fresh approach to his own art. He must have been deeply impressed by the decorative refinements of the Ukiyo-e woodcuts—the subtle use of line, the daring foreshortenings, and unusual organization of space—for these distinctive qualities found their way into his work in about 1875, when he began to direct his efforts toward subjects drawn, as Ukiyo-e art was, from contemporary life.

Like the eighteenth-century Japanese printmakers Harunobu and Utamaro, Degas spent the better part of his life making pictures of women: women engaged in their toilettes, their daily chores, and the diversions of social company. He was captivated by the spontaneous, natural positions into which the most ordinary women's bodies move. Just as the Ukiyo-e masters had rebelled against the conventional academic subjects of their day and turned to the life of the city, its shopgirls and courtesans, Degas rejected legendary goddesses and queens in favor of Parisian laundresses and ballerinas. "Two centuries ago," Degas declared, "I would have painted Susannah at the bath. Today, I paint only women in their tubs."

It may have been Harunobu's woodcuts[7] of doll-like couples that prompted Degas to place just two figures in some of his compositions, although the practice among French painters then was to employ, for balance, three. Degas's experimental aquatint The Two Dancers (1876–77) (30), which marks the beginning of his most inventive printmaking period, and his two etchings of Mary Cassatt at the Louvre, done between 1879–80, share with Harunobu's prints (31) not only similarities of subject, composition, and scale but also the same evocative mood. Degas followed Harunobu's formula: one figure standing, one seated, each quietly absorbed. The figures are set against a framework of lines that define verandas and sliding screens in the Japa-

31 Attributed to SUZUKI HARUNOBU, 1725–1770

*Young man greeted by a woman writing a poem. Color woodcut*

The Metropolitan Museum of Art. The H. O. Havemeyer Collection. Bequest of Mrs. H. O. Havemeyer, 1929. no. 1628

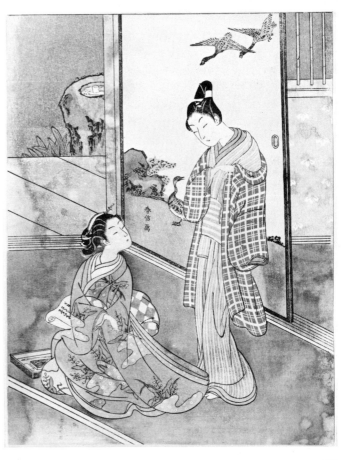

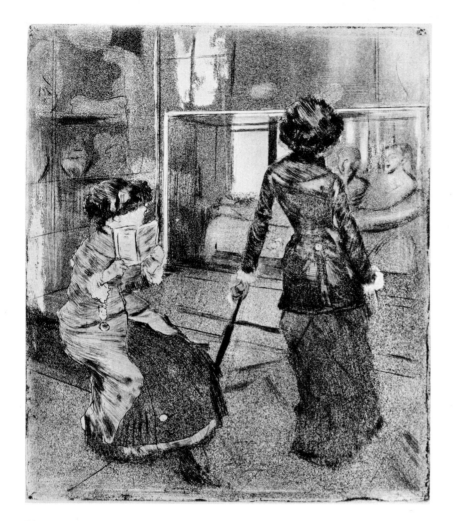

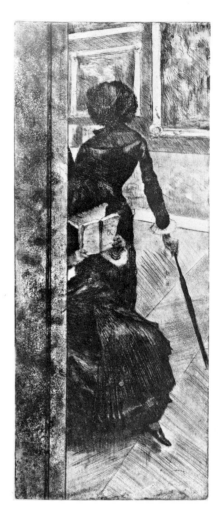

32 EDGAR DEGAS

*At the Louvre: Mary Cassatt in the Etruscan Gallery.*
*Etching, aquatint, and crayon electrique, third state.*
*1879–80*

The Metropolitan Museum of Art. Rogers Fund, 19.29.2

33 EDGAR DEGAS

*At the Louvre: Mary Cassatt in the Paintings Gallery.*
*Etching (hard- and soft-ground), aquatint, drypoint, and*
*crayon electrique, twentieth state. 1879–80*
Prints Division, New York Public Library, Samuel P. Avery
Collection

nese woodcuts, stage sets and parquet floors in
Degas's etchings. In both the space is tightly
enclosed and viewed from the high vantage point
ruled by oriental perspective.

Like Harunobu's demure women, the dancers
in Degas's print are one-dimensional ornaments
more than they are human beings. Through their
gestures and poses they project a certain de-
tachment. The same pensive mood permeates
Degas's two etchings of Mary Cassatt visiting the
Louvre—technically his most complex prints
(*32, 33*). Both were done about 1879–80, when

Degas was collaborating with Pissarro, Cassatt,
and Bracquemond on the founding of a journal of
prints to be called "Le Jour et La Nuit." Their
first contributions to this magazine—which, for
lack of funds, was never published—were done in
an aquatint that produced a gray and grainy sur-
face tone similar to the gray washes printed from
Japanese woodblocks. In innumerable woodcuts
by Harunobu, silvery gray and gray green back-
grounds function as the aquatint does in Degas's
prints, to harmoniously blend figures and setting
in one continuous texture.[8]

36

Degas, the most ingenious technician of all the impressionist printmakers, labored assiduously to perfect the aquatinting of his plates. He conferred with Bracquemond, the acknowledged technical adviser to the group, and with Pissarro, to whom he proposed another complex printmaking procedure, involving printing color with woodblocks, like the Japanese. In 1880 Degas wrote to Pissarro regarding their experiments:

*I have also other ideas for the color plates. . . . Can you find anyone at Pontoise who is able to cut out of very thin copper things traced by you? This sort of pattern might be placed on a line or soft ground etching, and by means of porous woodblocks saturated with watercolor the uncovered parts printed. Some pretty trial prints in color, original and curious, might thus be produced. . . . I will shortly send you some experiments of my own in that direction. It would be economical and a novelty. . . .*[9]

What results these experimental ideas yielded are unfortunately unknown. Had they succeeded, they would have marked a new stage in the development of European color printing, predating Gauguin's revolutionary color woodcuts by more than a decade. (Later Degas printed monotypes in color; Cassatt and Pissarro made color etchings.)

At the Louvre: Mary Cassatt in the Paintings Gallery (*33*) is the most deliberately "Japanese" of Degas's prints, the most successful in fusing a momentary view with a decorative arrangement. It contains the Japanese characteristics most frequently pointed to in Degas's art: aerial perspective, asymmetrical composition, and a casual snapshot effect aided by the cutting off of figures by the picture's edge. The tall, narrow format derives from Japanese *hashira-e,* prints designed for display on the pillars of houses. The etching follows Harunobu's pillar prints of about 1768 (*34*), not only in shape but in its restrained mood and in the compression of overlapping figures into a carefully articulated, shallow space. Its oriental look is reinforced by the strip of marbleized doorway at the left, which crops the figures in

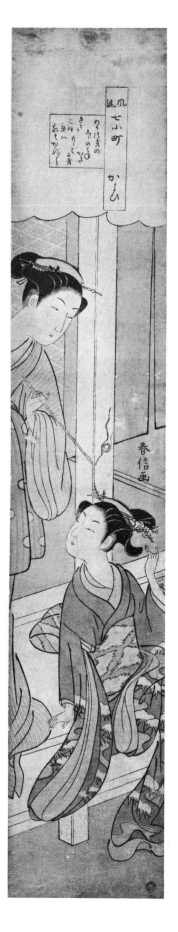

34 SUZUKI HARUNOBU, 1725–1770

Kayoi Komachi. *Color woodcut, pillar print, from the series* The Seven Fashionable Komachi

The Metropolitan Museum of Art. Frederick Charles Hewitt Bequest Income, 1912. no. 671

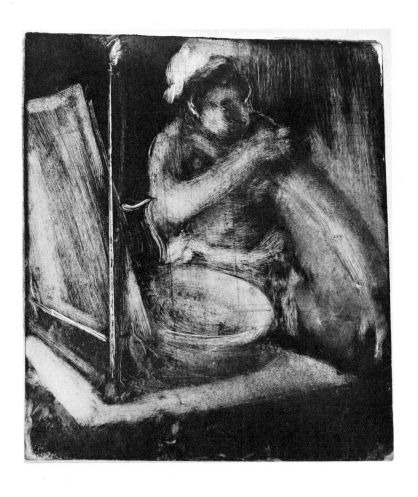

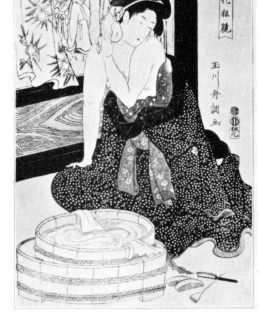

35 EDGAR DEGAS

*La Toilette (Les Bras). Monotype. About 1880–85*

Grunwald Center for the Graphic Arts, University of California,
Los Angeles

36 TAMAGAWA SHUCHŌ, active about 1789–1800

*Woman taking a sponge bath. Woodcut*

Ex. coll. Alexis Rouart

37 (OPPOSITE PAGE) EDGAR DEGAS

*Leaving the Bath. Crayon electrique, etching, drypoint,
and aquatint, eighth state. About 1882*

The Metropolitan Museum of Art. Rogers Fund, 21.39.1

an unexpected manner and doubles for the
brocade mounting on *kakemono-e,* or hanging
scrolls.

The similarity between Degas's compositions
and those of Japanese printmakers was noted at
least as early as 1880 when Huysmans noted the
way figures were cropped "as in some Japanese
prints." The Japanese must have suggested to
Degas the possibilities of cutting figures slightly
by columns, screens, or, as seen here, by a door-
way. However, it was more likely Degas's interest
in photography that prompted the abrupt crop-
ping of heads and legs that occurs in his paintings.

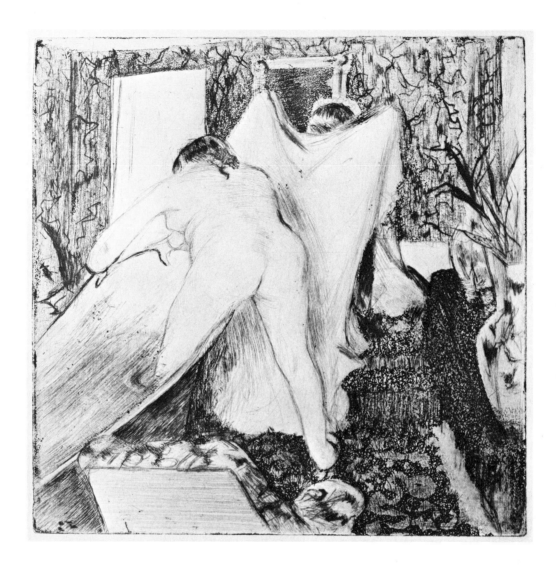

Such radical cropping seldom appears in Japanese prints.[10]

The Japanese probably did direct Degas's attention to the spontaneous subjects that made up Ukiyo-e art but had seemed graceless to western eyes. Many of Degas's nonchalant bourgeois bathers (*35*) owe their existence to Hokusai's peasant women, awkwardly bent over their wash tubs, legs akimbo, elbows askew, or to loosely robed bathers like the one in a print by Shuchō (*36*), once in the collection of Degas's friend Rouart.

After about 1880 Degas devoted his energy to the bather, whom he treated in paintings, drawings, sculpture, and prints. He made two small etchings of nudes about 1882, in which the diminutive figures were virtually absorbed into their settings (*37*). Degas concentrated less on the figure itself than on the activation of the entire picture surface with patterned wallpapers, carpets, and upholstery. The impetus again came from the Japanese printmakers, who enriched their woodcuts with decoratively patterned kimonos and wall hangings and emphasized patterns wherever they appeared in nature.

In six lithographs done between 1880 and 1892

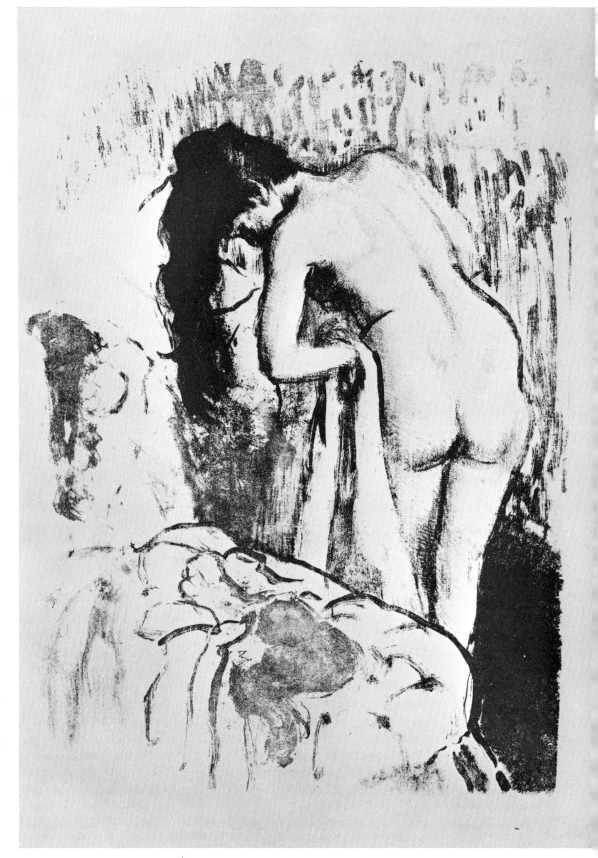

**38 EDGAR DEGAS**

*Femme nue debout, à
sa toilette. Lithograph,
third state. About
1890–92*

The Metropolitan Museum
of Art. Gift of Mr. and
Mrs. C. Douglas Dillon,
1972.626

40

Degas concentrated on the form and volume of the bather's body. Lithography allowed him greater ease of drawing and a fluid line to define body contours. All six of his lithographed bathers feature essentially the same monumental figure bending over to dry herself with a towel (*38*). She is pictured from behind, as are many women in Japanese prints. (The Japanese thought a woman's back and the nape of her neck were her most expressive and appealing physical features.) That Degas's bather is sometimes accompanied by a maidservant (*41*) may also be an inspiration of Ukiyo-e woodcuts, in which courtesans are frequently attended by servants who administer toilet articles or wait with dressing gowns readied (*40*). Beginning about 1875, Degas often drew nudes combing or arranging their hair, a frequent subject of Ukiyo-e prints. A woman bent over, combing a dark stream of hair in one of Kitagawa Utamaro's *Ten Forms of Feminine Physiognomy* (about 1802) prefigures Degas's bathers with falling tresses (*38, 39*). Similarly,

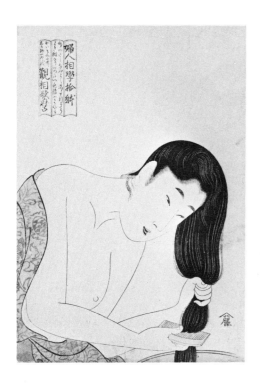

39 KITAGAWA UTAMARO, 1753–1806

*Woman combing her hair. Color woodcut from the Series* Ten Forms of Feminine Physiognomy. *About 1802*

Courtesy of the Trustees of the British Museum, London

40 ISODA KORYŪSAI, active 1766–1788

*A woman examining a robe held by another woman. Color woodcut*

The Metropolitan Museum of Art. Gift of Francis M. Weld, 1949. no. 3140

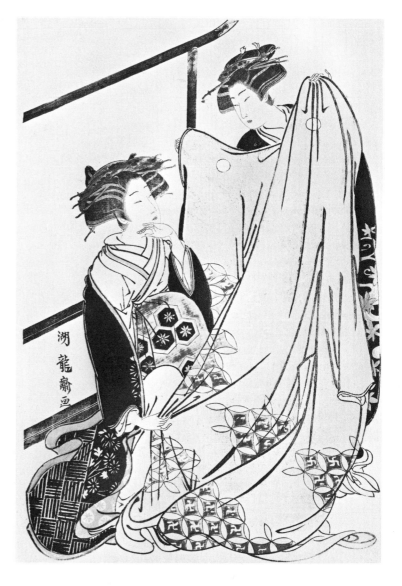

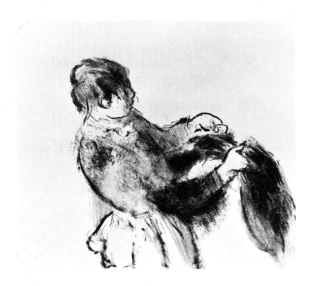

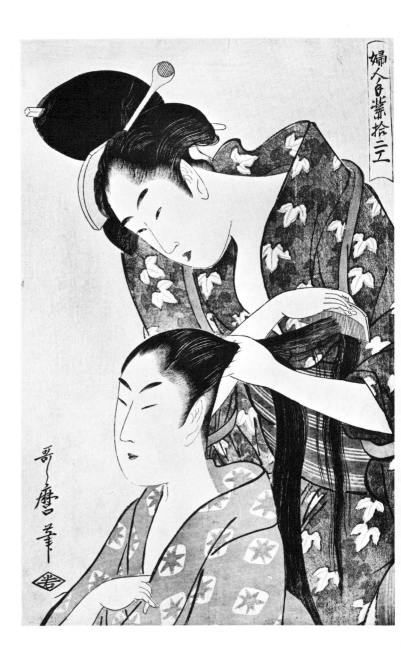

Degas's lithograph of A Maidservant Combing a Woman's Hair (about 1890) could have been inspired by one of Utamaro's *Twelve Forms of Women's Handiwork,* which treats the same subject (*41, 42*).[11]

Utamaro must have provided fresh and singular confirmation of the lessons of Ingres, whom Degas revered. Utamaro combined a delicacy of drawing with monumental dignity in his portrayals of women of all ranks. The Ukiyo-e master's prints were among those most avidly collected by Degas's contemporaries. Over a hundred Utamaro woodcuts from various collections were exhibited at the École des Beaux-Arts in 1890, and Utamaro earned the title of "founder of the school of life" from Edmond de Goncourt, whose monograph on him was published in 1891. The critic Gustave Geffroy declared of Utamaro's skill in depicting women: "He always draws from them a certain serenity, and always his pure, flexible line enhances the grace and slenderness of their bodies.[12]

Degas's pursuit of honesty in depicting women led him, as it had Utamaro and so many Ukiyo-e artists, to houses of prostitution. Naturalist writers had just introduced the brothel into French literature when, in 1876, Degas amused himself by sketching illustrations for the Goncourt brothers' novel about prostitutes, *La Fille Elisa.* Later, between 1879 and 1880, Degas printed over fifty monotypes of prostitutes,[13] which revealed

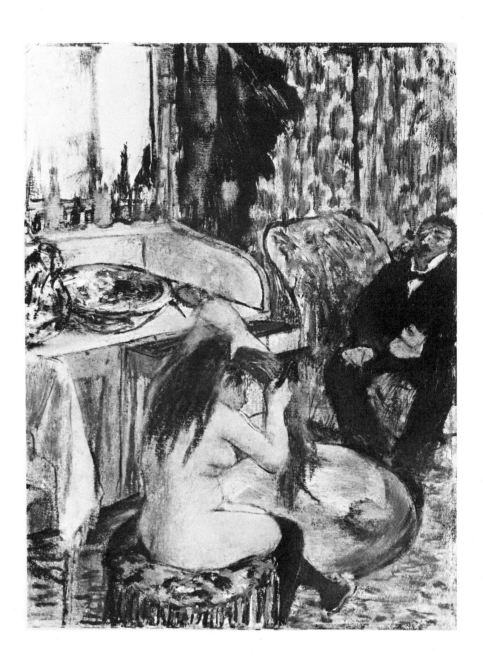

43 EDGAR DEGAS

*Femme nue se coiffant. Monotype.*
*About 1877–79*

Ittleson Collection, New York

the dull routine of brothel life (*43*). Unlike Utamaro's statuesque courtesans, Degas's women are unappealingly pudgy and vulgar. But they are pictured in scenes as sordid and brutally realistic as the Japanese illustrations for erotic volumes called "shunga" ("spring pictures"), of which the Goncourt brothers, Émile Zola, and other Japanese print collectors had numerous examples and which, no doubt, exerted a powerful influence on Degas.

The most literate and articulate of the impres-

sionist painters, Degas was also the most visually sophisticated. His wide-ranging tastes encompassed classical art, Assyrian art, the early Italians, and the sixteenth-century Venetians, as well as Delacroix, Ingres, Daumier, and his own contemporaries. He had an apparently limitless capacity for visual experience, all of which enriched his art. One of the miracles of Degas's genius was that whatever he absorbed from these diverse sources yielded its own identity to his.

Japanese prints confirmed Degas's beliefs

about the meaning and purpose of art. He shared with the Ukiyo-e masters a heightened awareness of the world about him, an eye for the unusual in the everyday, the remarkable in the ordinary, the timeless in the momentary. He respected a cultural heritage that encouraged the development of such instincts; when he saw a young Japanese studying painting at the École des Beaux-Arts, Degas exclaimed: "When one has the good fortune to be born in Japan, why come here to subject oneself to the discipline of professors...?"[14]

Nothing could have been further from the traditions of Old Master painting, in which Degas was firmly rooted, than the arbitrary and schematic Japanese prints. But Degas, who was more a draughtsman than he was a painter, expressed himself best in line and design and was therefore naturally drawn to Ukiyo-e woodcuts. Rather than imitate them, however, he discriminately selected those eastern traits that could be absorbed within the framework of his western heritage. Our enduring fascination with Degas's art results from the intriguing tension between its fundamentally European realism and the Japanese direction of its simplified, decorative design.

1. The incident is related by Julius Meier-Graefe in his book *Degas* (New York, 1923), p. 65.

2. P. A. Lemoisne, *Degas et son Oeuvre* (Paris, 1946), vol. I, pp. 176–80.

3. The sale catalogue lists these prints only summarily as follows:
   Kiyonaga: Le Bain des Femmes
   Kiyonaga: Cent Qualités de Femmes (2 albums)
   Utamaro: Le Passage du gué (triptych)
   Utamaro: Promenade en barque (triptych)
   Group of 42 landscapes by Hiroshige
   Miscellaneous lot of 14 albums
   Miscellaneous lot of 41 prints by Yeizan, Utamaro, Shunshō, Yeisho, Toyokuni, Shunman, Hokusai, etc.
   Fifteen drawings by Hokusai

4. George Moore, *Impressions and Opinions* (New York, 1891), p. 306.

5. This suggestion is made by Theodore Reff ("The Pictures within Degas's Pictures," *Metropolitan Museum Journal,* vol. 1, 1968, p. 137), who notes mention of Tissot's Japanese projects in a letter of Dante Gabriel Rossetti, written in 1864: "I went to the Japanese shop [of Mme de Soye] but found that all the costumes were being snapped up by a French artist, Tissot, who it seems is doing three Japanese pictures, which the mistress of the shop described to me as the three wonders of the world."

6. Like Pissarro and other impressionists, Degas painted a few fans in the Japanese manner (about 1879) and did a few paintings on china.

7. Prints by Suzuki Harunobu (about 1725–1770) could be seen in numerous Parisian collections. The Goncourts, according to the 1897 catalogue of the sale of their collection, owned at least seventy-five of them. When the print collection of Degas's friends Alexis and Henri Rouart was dispersed in 1922, the sale catalogue listed twenty-nine. Forty-six Harunobu woodcuts from various collections were exhibited at the École des Beaux-Arts in 1890.

8. Félix Fénéon drew a comparison between the "manière grise" and characteristics of Japanese art when he saw Pissarro's aquatint for "Le Jour et La Nuit," Paysage à l'Hermitage, at Durand-Ruel: "Que nous sachions, MM. Degas, Bracquemond et Pissarro ont seuls fourni des spécimens de ce procédé qui permet de donner la légèreté d'une poussière à ce semis de points repandus comme par le Japonais Issai" (essay "Les Peintres Graveurs" first published in *La Cravache,* February 2, 1889).

9. Degas, *Lettres,* ed. M. Guérin (Paris, 1945), pp. 52–54.

10. The influence of photography on Degas is discussed by Aaron Scharf in his book *Art and Photography* (London, 1968).

11. Other Japanese print sources for Degas's art are tentatively suggested in the following: Taichiro Kobayashi, *Hokusai to Degas* (Osaka, 1946); Y. Shinoda, *Degas, der Einzug des Japanischen in die französische Malerei* (Tokyo, 1957).

12. Gustave Geffroy, "Utamaro" essay in *La Vie Artistique* (Paris, 1892), first published May 28, 1890.

13. See Eugenia Parry Janis, *Degas Monotypes* (Cambridge, Mass.: Harvard University, 1968), pp. xix–xxi.

14. Quoted in Paul Lafond, *Degas* (Paris, 1918), vol. I, p. 148.

# Mary Cassatt

Even if they had not been an established vogue among the impressionists, Japanese prints would have compelled Mary Cassatt. She "hated conventional art," and in 1877, when Degas invited her to join the impressionists in reaction to the boring academy, she happily allied with the rebels. She was thirty-three; she had spurned Philadelphia society to settle and study art in France; and, at last, she declared, "I began to live."[1]

Degas's etchings of Cassatt studying the paintings and Etruscan sculpture of the Louvre (*32, 33*) are early clues to her conversance with art of all kinds. This intellectual woman, a passionate reader of history and archaeology, had a discriminating eye and a visual memory of uncanny accuracy. To develop her own art she studied the paintings of Correggio, Rubens, Courbet, Manet, and Degas; to perfect her printmaking she focused on the Japanese.

Cassatt had seen Ukiyo-e woodcuts prior to the large exhibition at the École des Beaux-Arts in the spring of 1890. (She had long been friends with Japanese art enthusiasts Degas, Pissarro, and Bracquemond.) But after seeing that impressive show, which she visited at least twice—once with Degas and once with Berthe Morisot—she deliberately modeled a set of her own prints after specific Ukiyo-e.

Cassatt made her first prints in about 1879. She began modestly, apparently on the advice of Degas, who suggested she draw on copper as an exacting discipline. By 1880, with In the Opera Box—her contribution to Degas's abortive journal, "Le Jour et La Nuit"—Cassatt's Japanism surfaced. Bracquemond and Degas then taught

her soft-ground etching and aquatint, and with those techniques mastered, she achieved decorative arrangements of flat curving shapes that prefigured the more intense orientalizing of her prints a decade later.

The doors had scarcely closed on the Beaux-Arts exhibition when Cassatt began work on her set of ten color aquatints done as "an imitation of Japanese methods."[2] These are her most ambitious prints and her most original contribution to printmaking history. The series' charms lie in its commonplace scenes—a woman bathing, embracing a child, or riding the tramway—scenes simply described and consciously ornamented. The prints were technically so lush and innovative that Pissarro, after seeing them in 1891, marveled in a letter to his son: ". . . the result is admirable, as beautiful as Japanese work, and it's done with printer's ink."

As she transplanted Ukiyo-e bathers and kimonoed mothers to French boudoirs, Cassatt converted the medium of the Japanese color woodcut to the processes she knew best: using metal plates instead of woodblocks, she drew in drypoint over broad soft-ground etching lines; the colors were applied by hand to an aquatint ground. Sometimes, like the Japanese, Cassatt had to prepare additional plates in order to align varied colors and patterns in the same picture. Printing the plates was a monumental task. For the summer and fall of 1890 Cassatt rented the Château Bachivillers on the Oise, set up her etching press there, and hired a professional printer, M. Leroy, to assist her in pulling twenty-five impressions of each image. "The printing [was] a

great work," Cassatt remarked. "Sometimes we worked all day (eight hours) both as hard as we could work and only printed eight or ten proofs in the day."[3] Not since the eighteenth century in France had a printmaker been so totally committed to color aquatint.

Modern students of Cassatt often minimize the literalness of her borrowings from the Japanese, emphasizing instead her prints' stylistic affinities with Ukiyo-e: simple outlines, flat colors, and multiple patterns. Clearly, however, several of the prints were modeled closely after woodcuts by the eighteenth-century master Kitagawa Utamaro, whose works Cassatt herself owned.[4] Eighty-nine prints and sixteen illustrated books by Utamaro were included in the Beaux-Arts exhibition; only Hokusai was better represented. Cassatt must have been greatly impressed by the display. She copied Utamaro's themes, his compositions, his colors, even some of his wispy-haired oriental heads. She also borrowed the print format Utamaro generally used, the upright ōban, about fifteen by ten inches. As a result, her color aquatints were larger than most contemporary French prints.

Utamaro's intimate treatment of motherly love immediately endeared his art to Cassatt. No artist of the Ukiyo-e school handled scenes of parent/child relationship more sympathetically than he. His honest, uncluttered views were devoid of the sentimentality that plagued most nineteenth-century European attempts. Cassatt first approached the mother/child theme via Correggio; she introduced it in her drypoint sketches about 1889. But not until her encounter with Utamaro's prints was her handling of the subject fully realized. Cassatt's first attempt to follow Utamaro's mode, The Tub (44, 45),[5] was cautious (she was still struggling with the technical difficulties of imitating the color woodcut

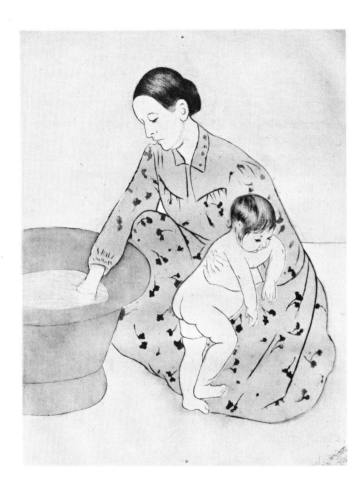

44 MARY CASSATT, 1845–1926

*The Tub. Drypoint, soft-ground etching, and aquatint, eleventh state; printed in color; from a series of ten. 1891*

The Metropolitan Museum of Art. Gift of Paul J. Sachs, 16.2.7

45 KITAGAWA UTAMARO, 1753–1806

*Woman bathing a baby in a tub. Color woodcut*

The Metropolitan Museum of Art. The H. O. Havemeyer Collection. Bequest of Mrs. H. O. Havemeyer, 1929. no. 1661

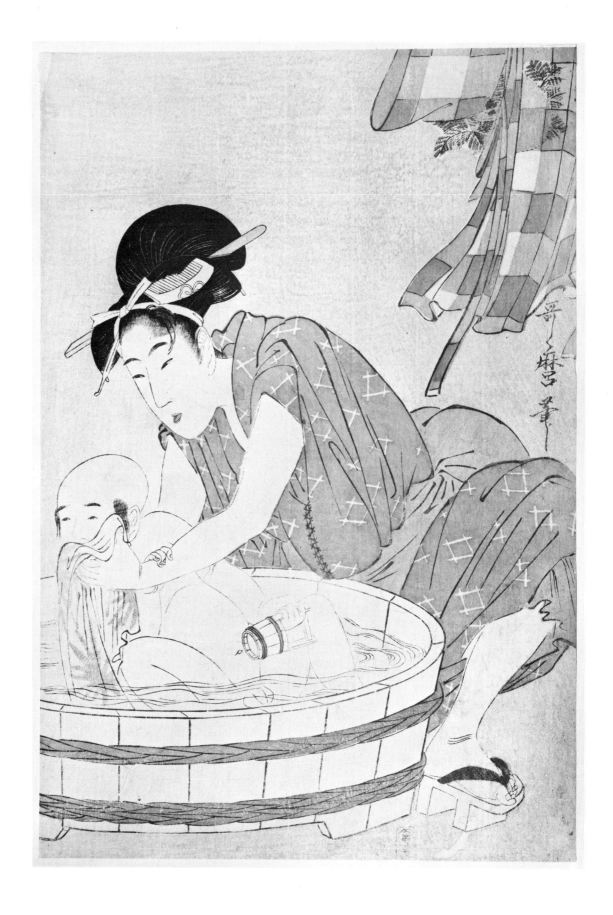

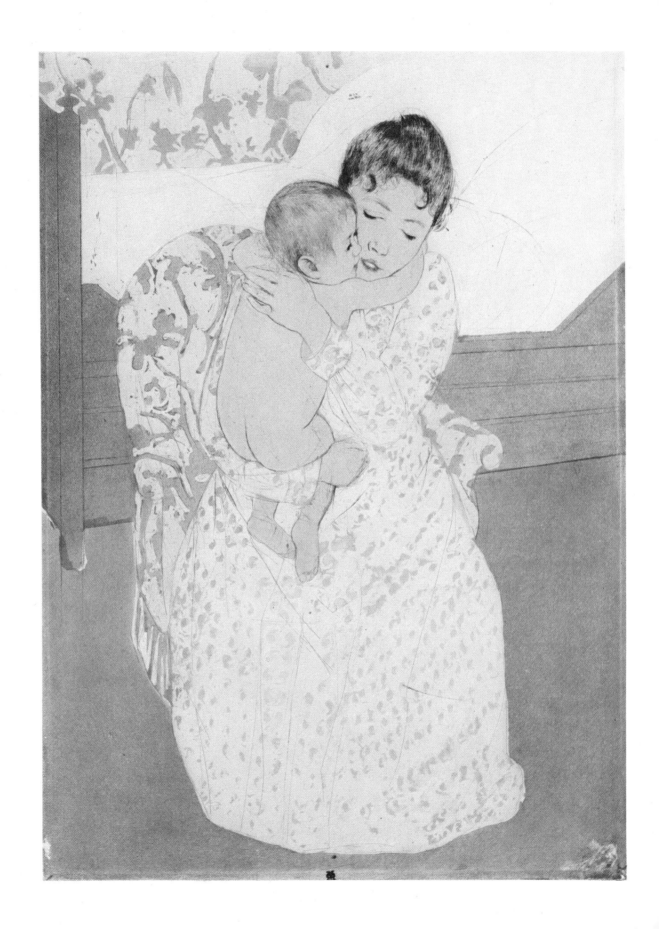

48

process). But the later Maternal Caress (46) demonstrates a comfortable meeting of the Japanese manner (47) and her own. Cassatt adopted Utamaro's down-to-earth viewpoint, and his intertwining of material and child forms, his flatly colored masses against the counterpoint of embroidered patterns. In her clear-headed treatment of mothers and infants Cassatt was, for her time, entirely alone. "The bunch of English and French daubers have put them in such stupid and pretentious poses!" complained the critic Huysmans of contemporary children's portraits, contrasting them with Cassatt's "irreproachable pearls of Oriental sweetness." [6]

However receptive she was to Utamaro's sincerity, Cassatt always maintained the fine-bred reserve that kept her subject matter within accepted bounds and her children, unlike Utamaro's, well behaved. Cassatt's essential conservatism may have limited the appeal Utamaro's looser compositions could hold for her, as they were frequently extreme close-ups, daringly cropped.

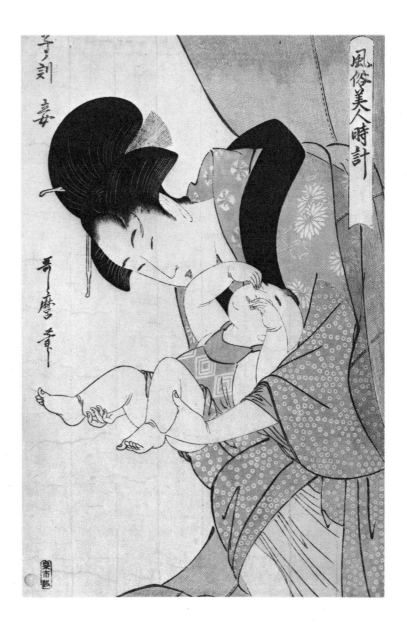

46 MARY CASSATT

*Maternal Caress. Drypoint, soft-ground etching, and aquatint, third state; printed in color; from a series of ten. 1891*

The Metropolitan Museum of Art. Gift of Paul J. Sachs, 16.2.5

47 KITAGAWA UTAMARO, 1753–1806

*Mother and sleepy child: midnight, the hour of the rat. Color woodcut from the series* Customs of Women in Twelve Hours. *About 1795*

The Metropolitan Museum of Art. Rogers Fund, 1922. no. 1278

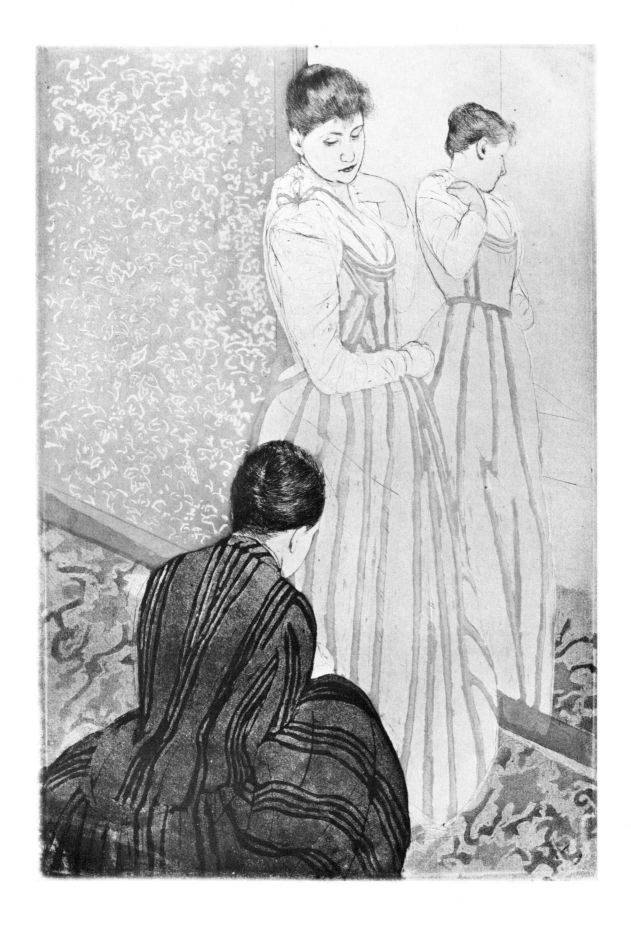

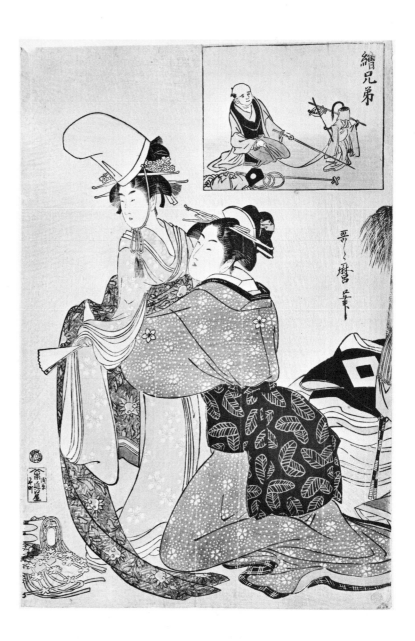

In most all her ten color prints Cassatt placed her figures in secure surroundings instead of Utamaro's open space.

The assurance and credibility of Mary Cassatt's pictures rise from her having wisely kept to the subjects she knew best. When she drew a woman at a dressmaker's fitting (*48*) or sealing a letter (*50*), she did so as a gentlewoman of means, accustomed to cultivated living and fashionable dress. Utamaro's seeming familiarity with her own daily experiences was a revelation that no doubt

49 KITAGAWA UTAMARO, 1753–1806

*Woman dressing a girl for the sanbaso dance; in the background, for comparison, a dancing monkey and his trainer. Color woodcut from the series* Brother Pictures, *or* Analogues

The Metropolitan Museum of Art. Samuel Isham Gift, 1914. no. 985

48 MARY CASSATT

*The Fitting. Drypoint, soft-ground etching, and aquatint, third state; printed in color; from a series of ten. 1891*

The Metropolitan Museum of Art. Gift of Paul J. Sachs, 16.2.8

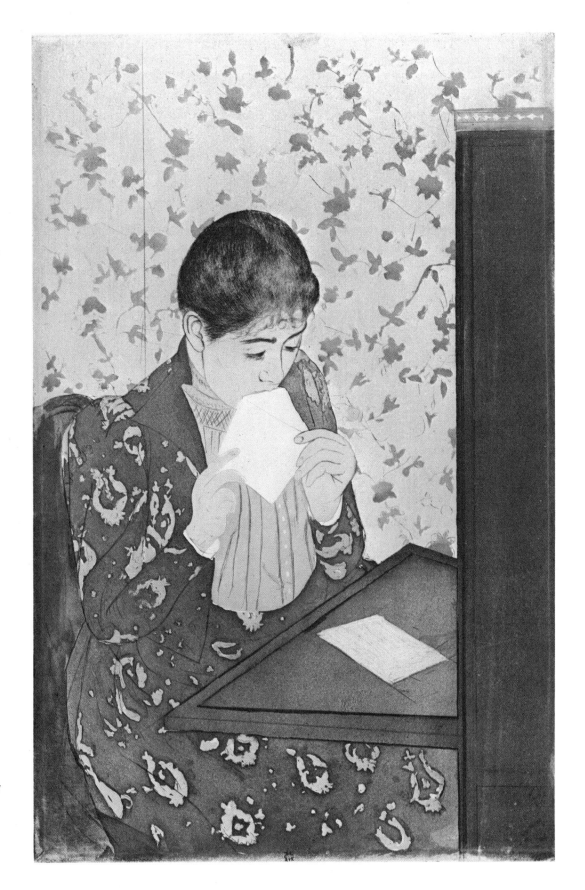

**50 MARY CASSATT**

*The Letter.* *Drypoint,*
*soft-ground etching, and*
*aquatint, third state;*
*printed in color; from a*
*series of ten. 1891*

The Metropolitan Museum of
Art. Gift of Paul J. Sachs,
16.2.9

pleased her. She appropriated the poses he used in woodcuts of courtesans attended by kneeling assistants (49) or holding paper or scarves to their lips (51). She adopted Ukiyo-e prints' elevated angle of vision and filled the resulting compositions with ornaments from kimono fabrics or with floral motives and paisleys from the Persian miniatures she collected. Utamaro's luscious hues, the "peachblossom pink," "sky blue," "honey yellow," and "tea green" became her colors too. There is always a suggestion of "oriental" modesty in her models' downcast gazes as well.

In three of her ten color aquatints (and in several other works as late as 1910) Mary Cassatt employed mirrors to reflect her subjects in double image. The mirror motif was a favorite with Utamaro, and he used it frequently in scenes of mothers and children and women at their toilettes (52). Cassatt's The Coiffure (53) and Woman Bathing (54) imitate Utamaro's device,[7] but more important, they are homages to the Ukiyo-e master's rhythmic and uncompromising line. "I do not admit that a woman can draw like that," remarked Degas when he saw Cassatt's prints. The rounded body contours were modeled with line alone, like his own grand bathers. Degas and Cassatt, the two most aristocratic impressionists, shared with Ukiyo-e a response to life's most humble incidents.

Though her color prints inevitably evoke their Japanese prototypes, the plates are distinguished by Cassatt's deliberate impress. Their look is more fragile and atmospheric than most Ukiyo-e woodcuts, and their mood is more reserved. The special stylized character of the aquatint set places it outside the mainstream of Cassatt's generally more naturalistic work. As these were to be featured in her first major public exhibition at the Durand-Ruel Galleries in April 1891, Cassatt worked very hard at them. Unlike most of her sketchy drypoints, which have the casual air of practice sheets, the aquatints have a fully orchestrated polish.

Later prints, like Feeding the Ducks and Gathering Fruit (about 1895) and her final attempts in the demanding color aquatint process in

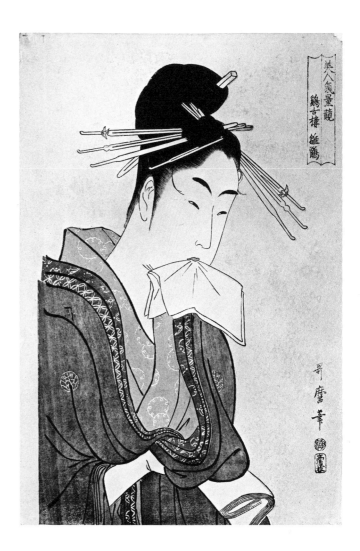

51 KITAGAWA UTAMARO, 1753–1806

*Portrait of the oiran Hinzauru. Color woodcut. About 1796*

Art Institute of Chicago

1898,[8] suggest Ukiyo-e compositions and decorative surfaces, but Cassatt's troubled eyesight had weakened her work. She could no longer match the Japanese prints' precision, but her memory of them did not dim. Her painter friend George Biddle visited Cassatt at her Château de Beaufresne near Beauvais shortly before her death in 1926. He noted that her own series of color aquatints lined the long corridor leading from her bedroom and formed a fitting complement to "the cold glass-covered veranda where hung the Utamaros . . ."[9]

52 KITAGAWA UTAMARO, 1753–1806

*Woman at her toilette, reflected in hand mirrors. Color woodcut*

The Metropolitan Museum of Art. Rogers Fund, 1914. no. 145

1. Achille Segard, *Mary Cassatt, Un Peintre des Enfants et des Mères* (Paris, 1913), p. 8.

2. See Cassatt's letter to Frank Weitenkampf, May 18, 1906, quoted in Frederick A. Sweet, *Miss Mary Cassatt, Impressionist from Pennsylvania* (Norman: University of Oklahoma Press, 1966), pp. 121–22.

3. Cassatt described the methods used in preparing and printing her series in this letter to Samuel P. Avery, January 9, 1903, and also in the 1906 letter to Weitenkampf cited above. Both are quoted in Sweet, *op. cit.*, pp. 120–22.

4. Japanese prints in Mary Cassatt's collection were auctioned at the Kende Galleries, Inc., New York, sale no. 389, April 22–23, 1950. The auction catalogue lists fifty-five prints under entries no. 56–89, including three woodcuts by Utamaro and nine others, unattributed, but presumably also by him (judging from descriptions given in the catalogue). Prints by Kiyonaga, Hokusai, Hiroshige, Harunobu, Eishi, and Eizan are also listed. I am indebted to Natalie Spassky, Associate Curator of American Paintings at The Metropolitan Museum of Art, for bringing the catalogue to my notice.

5. In the catalogue of Cassatt's exhibition at the Durand-Ruel Galleries in 1891, this print is described: "Essai d'imitation de l'estampe japonaise." Two prints by Utamaro, treating the same subject, were exhibited at the École des Beaux-Arts exhibition in 1890: no. 371, "Bain d'enfant," and no. 402, "Baignade d'enfants."

6. Quoted in Sweet, *op. cit.*, p. 60.

7. The catalogue of the exhibition of Japanese woodcuts at the École des Beaux-Arts in 1890 lists an Utamaro, no. 375: "Femme à sa toilette, examinant sa coiffure au moyen d'un double miroir"; the sale of Japanese prints from Cassatt's collection at the Kende Galleries in New York, 1950, lists an Utamaro print of a mother and child, their faces mirrored in a pool of water (cat. no. 82).

8. These close-up "snapshot" views suggest that Cassatt may have turned to photography for a new approach to spontaneous mother/child scenes.

9. George Biddle, "Some Memories of Mary Cassatt," *Arts* (August 1926) vol. 10, pp. 107–111.

54 MARY CASSATT

*Woman Bathing. Drypoint, soft-ground etching, and aquatint, fifth state; printed in color; from a series of ten. 1891*

The Metropolitan Museum of Art. Gift of Paul J. Sachs, 16.2.2

53 MARY CASSATT

*The Coiffure. Drypoint, soft-ground etching, and aquatint, fourth state; printed in color; from a series of ten. 1891*

The Metropolitan Museum of Art. Gift of Paul J. Sachs, 16.2.3

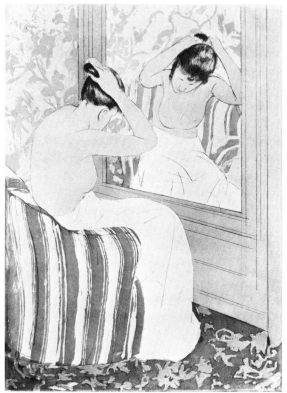

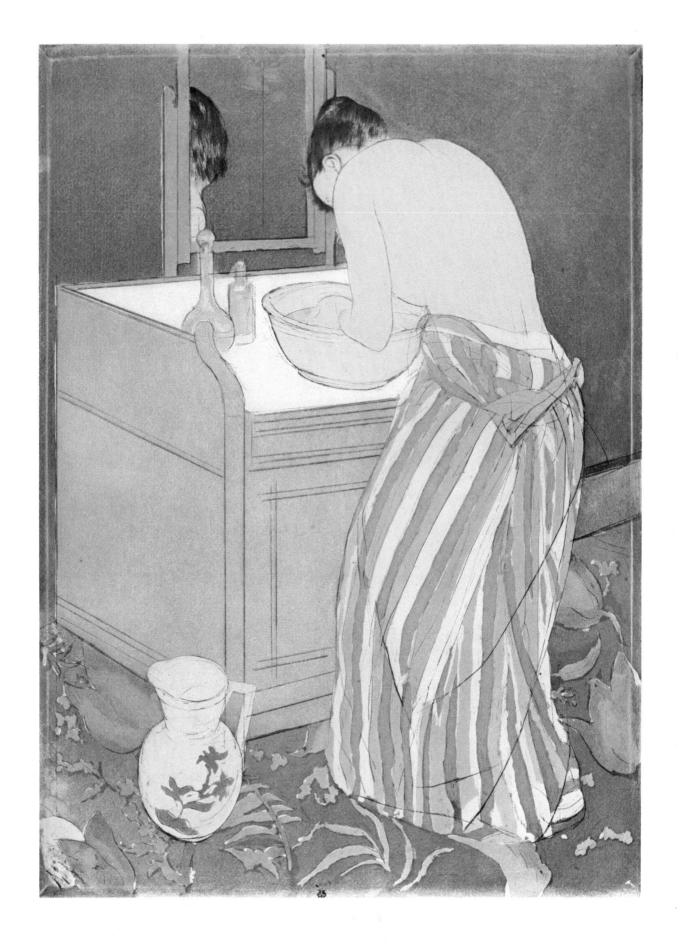

*Poster for France-Champagne. Color lithograph.*
*1889*

The Museum of Modern Art, New York. Abby Aldrich
Rockefeller Fund

# Pierre Bonnard

The young artists who banded together in 1889
to become "Nabis" ("prophets") of a new painting
style gave each other nicknames: Sérusier was
"the Nabi of the Sandy Beard," Vuillard "the
Zouave," and Bonnard, because he loved oriental
calligraphy and prints, was called "le Nabi très
japonard" ("the ultra-Japanese Nabi"). Practi-
cally all the members of his circle, including
Vuillard, Denis, Ibels, Vallotton, Ranson, and
Roussel showed oriental influences in their early
work. Denis noted that the potency of Japanese
art "spread like leaven" through the whole Nabi
movement.

Bonnard and his friends refused to submit

to French academic prejudices and, like the
rebellious Pre-Raphaelites in England, returned
to the simple, unaffected styles of earlier periods.
The group spent hours analyzing early Italian
and French painting and the clear-cut designs
of Ukiyo-e, whose "primitiveness" reinforced their
concept of art as decoration. Gauguin, whose
sweeping outlines and flat, bright colors so
enthralled the Nabis, had thoroughly indoc-
trinated them with his cult of the primitive before
sailing to the South Seas in 1891.

Bonnard was just beginning his career as an
artist when the Japanese craze reached its climax
in Paris. Less than a year after he abandoned law

school to pursue art, the large exhibition of Japanese prints opened at the École des Beaux-Arts, where he had been a student. Seeing over a thousand Ukiyo-e woodcuts must have been a staggering experience for him, even though he was already prepared to be impressed. He leafed through Japanese prints at Père Tanguy's shop and also at the Goupil Gallery, where Theo van Gogh worked, and purchased prints at a boutique on the avenue de l'Opéra.

That Ukiyo-e woodcuts were very much on his mind is evident in Bonnard's first print, a lithograph he designed as an advertisement for a wine merchant in 1889. The ebullient France-Champagne poster (55) mingles lessons learned from both Gauguin and the Japanese. Gauguin's exhibition the same year at the Café Volpini demonstrated his "synthetic" style of flat and broadly outlined masses; his recently published set of Breton lithographs (102, 104), which set fluid black lines against a vivid yellow paper, must also have caught Bonnard's eye. Like Gauguin, Bonnard emphasized the linear contours of his subjects, exaggerating the delicate network of Japanese woodcut lines for a bolder decorative effect. Furthermore, in a cascade of bubbling champagne he imitated Hokusai's famous woodcut of a "great wave" breaking into curls of foam (1). Hokusai's characteristic animation and verve also enliven the poster's gay Parisienne. This party girl, a spin-off from the contemporary posters of Jules Chéret, is as alluring as one of Utamaro's geishas (56) and similar in silhouette, as Signac observed when he wrote in his journal (September 29, 1894) of Bonnard's design: "... if one were to trace its outlines, one would get the contours of an Utamaro." So unusual and captivating was Bonnard's poster that when it appeared on Paris walls in 1891, another young artist, Toulouse-Lautrec, sought out its creator to learn more about poster making.

Some of Bonnard's earliest ventures into color lithography, like the anecdotal images drawn for the music albums *Petit Solfège* and *Scènes Familières,* are as sketchy as the inky little figures in Hokusai's *Manga.* Others depend upon the careful arrangement of color shapes that characterize the more classic prints of Utamaro.[1] "Those unprivileged images," said Bonnard of the mass-produced Ukiyo-e, "taught me that colour could express everything, without having to call on modeling or relief to help it out. It became clear to me that colour, all by itself, could convey light, convey form and convey character. Values need not be added."[2]

Bonnard soon eliminated Japanese woodcuts' black outlines to allow colored masses to float on

56 KITAGAWA UTAMARO, 1753–1806

*The "fickle type." Color woodcut from the series* Studies of Ten Kinds of Female Physiognomy. *About 1794*

Edith Ehrmann Collection, New York

**57 PIERRE BONNARD**

*Family scene. Color lithograph published in*
*L'Estampe Originale. 1893*

The Metropolitan Museum of Art. Rogers Fund,
22.82.1-3

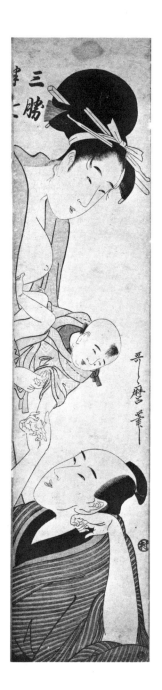

58

the surface of his prints. His lithograph, Family
Scene (*57*), published in *L'Estampe Originale*
in 1893 glimpses his sister's family in an intimate
close-up and characteristically celebrates the
tranquil pleasures of domesticity. Its subjects, like
the family group in Utamaro's pillar print (*58*),
are embraced by a tall frame and ornamented
with patterned fabric. (Bonnard was apt to delight
in a checked blouse as easily as in a baby's
bald head.)

There is an air of childlike innocence about
most of Bonnard's early prints, but none is more
deceptively simple than the Little Laundress (*59*)
of 1896, in which Bonnard treats a fleeting inci-
dent of everyday life with oriental brevity and
wit. The awkward figure with an umbrella,
trudging up a deserted street, repeats an Ukiyo-e
silhouette reproduced in the French periodical
*Le Japon Artistique* in 1891 (*60*). In his urchin
washwoman Bonnard suggests the vitality of
a Hokusai ink sketch and the piquant charm of
a Harunobu maiden (*61*).[3] The influence of
Japanese prints is apparent in the diagonal thrust
of the composition, the flattened shapes, a narrow
range of subtle colors, and the seemingly
unstudied details of the scene.

58 (OPPOSITE PAGE) KITAGAWA UTAMARO, 1753–1806

*Two lovers, Sankatsu and Hanhichi, with their baby. Color
woodcut, pillar print*

The Metropolitan Museum of Art. Rogers Fund, 1919. no. 1123

59 PIERRE BONNARD

*Little Laundress. Color lithograph. 1896*

The Metropolitan Museum of Art. Harris Brisbane Dick Fund,
39.102.3

60 *Woman walking with an umbrella, seen from behind.
Reproduction from a Japanese print, published in*
Le Japon Artistique, *March 1891*

The Metropolitan Museum of Art. Gift of Pierre L. Lebrun, 1922

61 Attributed to SUZUKI HARUNOBU, 1725–1770

*A young woman crossing a snow-covered bridge. Color
woodcut. 1765*

The Gale Collection. The Minneapolis Institute of Arts

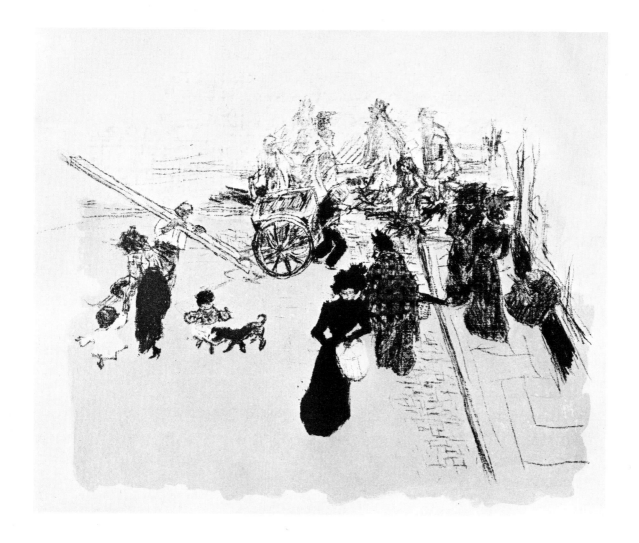

Among the Ukiyo-e woodcuts in Bonnard's own small collection were works signed by Kuniyoshi, Hiroshige, and Kunisada.[4] According to Bonnard's close friend Thadée Natanson, prints by the landscape master Hiroshige were most influential, as is evidenced by the set of twelve lithographs Bonnard published as *Quelques aspects de la vie de Paris* in 1899. This collection of Paris views perpetuates the spirit of Hiroshige, whose myriad picture prints of Edo (Tokyo) and the sights along Japan's major roads (1830–55) were popular with French collectors and well

62 PIERRE BONNARD

*Street Corner. Color lithograph from the series* Some Aspects of Paris Life. *1899*

The Metropolitan Museum of Art. Harris Brisbane Dick Fund, 28.50.4 (3)

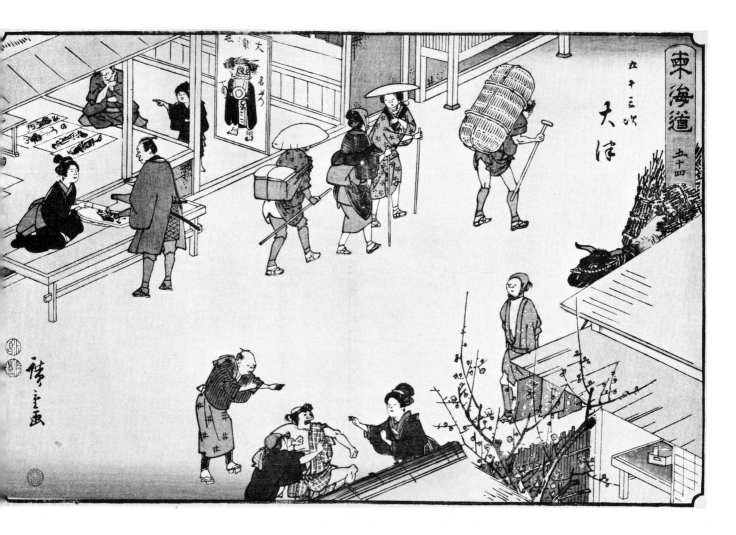

63 ANDŌ HIROSHIGE, 1791–1858

*Otsu no. 54: village street in early spring with printseller's shop. Color woodcut from the series*
Fifty-three Stages of the Tōkaidō. *About 1845–53*

The Metropolitan Museum of Art. Frederick Charles Hewitt Bequest Income, 1912. no. 804

represented in Ukiyo-e exhibitions during the 1890s.[5] Both Hiroshige and Bonnard captured the animated life of the city in casual scenes of crowded boulevards, bridges, and back streets. From a variety of vantage points they kept ever on the lookout for the anecdotal and picturesque in the urban scheme.

Bonnard's color lithographs repeat themes of paintings he did about 1897–98 and reproduce their atmospheric quality in sketchy crayon. The painterly touch to these later prints contrasts with Bonnard's earlier lithograph style that sought

to imitate Japanese woodcuts' well-carved shapes. The point of view, however, remains oriental.

As he strolled the boulevard de Clichy or place Pigalle, Bonnard observed the flower vendors, nursemaids, and waifs that figure in his *Street Corner (62)*. Their fleeting forms dot a gray green swath as the inventively positioned street people do in Hiroshige's view from the Marusei Tōkaidō *(63)*. The pictorial arrangement is the sort that prompted Clive Bell to remark: "Bonnard's pictures as a rule grow not as trees; they float as water lilies."[6]

61

The spell of Hiroshige and Ukiyo-e landscape is cast upon Bonnard's entire suite of color prints. Hiroshige was universally acclaimed for his mastery of wind and weather effects so beloved by the impressionists. His Ōhashi (bridge) in Rain had been painstakingly copied by van Gogh between 1886–88. Articles on Hiroshige's prints appeared in *Le Japon Artistique* in July and August 1889, and one of his stormy scenes was reproduced in that periodical (*64*). Hiroshige's view of scurrying people enveloped in rain and darkness may have been the inspiration for Bonnard's lithograph Street at Evening, in the Rain (*65*).

Bonnard frequently tilted up the picture plane in the oriental manner. In The Bridge (*66*) an elevated horizon is lined with shadow-play carriages and shoppers, echoing a popular treatment of bridges in Ukiyo-e woodcuts.[7] Théodore Duret, in an essay on Hokusai first published in the

64 ANDŌ HIROSHIGE, 1791–1858

*Suwara no. 40: travelers in a teahouse taking shelter from heavy rain. Color woodcut from the series The* Sixty-nine Stations on the Kisokaidō. *About 1840*

The Metropolitan Museum of Art. The Henry L. Phillips Collection, Bequest of Henry L. Phillips, 1940. no. 2868

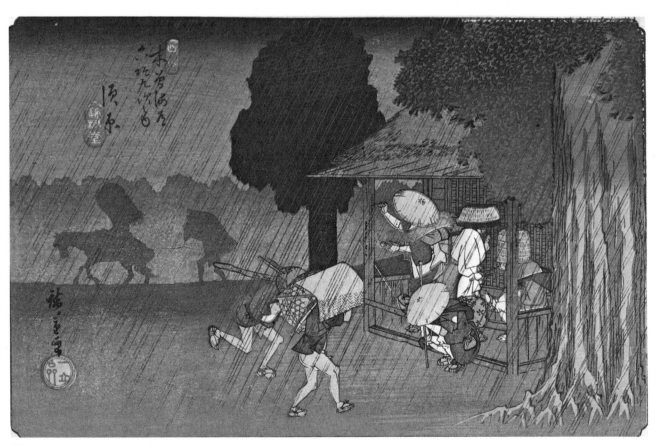

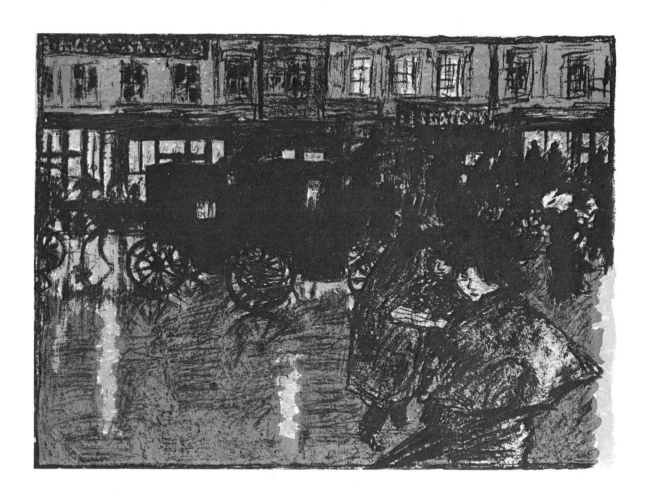

65  PIERRE BONNARD

*Street at Evening, in the Rain.*
*Color lithograph from the series*
Some Aspects of Paris Life. *1899*

The Metropolitan Museum of Art. Harris
Brisbane Dick Fund, 28.50.4.(11)

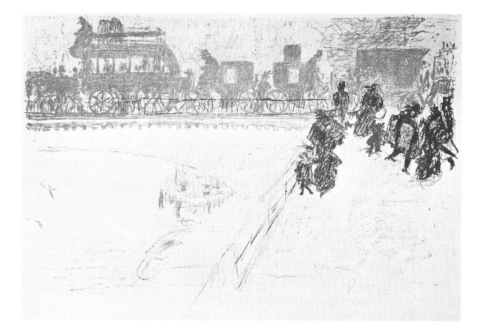

66  PIERRE BONNARD

*The Bridge (Pont des Arts). Color*
*lithograph from the series* Some
Aspects of Paris Life. *1899*

The Metropolitan Museum of Art. Harris
Brisbane Dick Fund, 28.50.4(9)

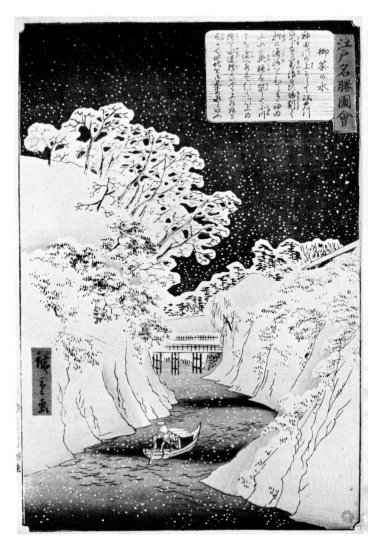

67 PIERRE BONNARD

*View from Above. Color lithograph from the series*
Some Aspects of Paris Life. *1899*

The Metropolitan Museum of Art. Harris Brisbane Dick Fund,
28.50.4(5)

68 HIROSHIGE II (Shigenobu), active about 1839–1864

*Snow scene at Ochanomizu. Color woodcut from the series*
Famous Beautiful Places in Edo

The Metropolitan Museum of Art. Rogers Fund, 1919. no. 1128

*Gazette des Beaux-Arts* in 1882, pointed to the
Japanese landscape style "as seen from high
above, with a perspective which lifts distant
planes up to the top of the picture and makes
people and objects stand out not against the back-
ground of sky, but against the background of the
landscape itself." Bonnard adopted this bird's-eye
perspective in his View from Above (*67*), which
is distinctively oriental also in its use of an
upright format for landscape. A flickering abstrac-
tion, in which both near and far are inseparably
interwoven, this print inevitably recalls the
lyrical Japanese landscape style (*68*).

Although generally unappreciated in his own
time, Bonnard's lavish portfolio of color litho-
graphs represents the culmination of the Japanese
influence in his work. Yet he had delivered
another tribute to *japonisme*: a set of four litho-
graphs hinged together in perhaps the most
significant creation of Japanese decorative style,

the folding screen (69). In the second half of the nineteenth century screens had become indispensable fixtures in well-appointed living rooms and boudoirs. As George Moore pointed out in his *Impressions and Opinions* (1891), "turkey carpets" and "Japanese screens" were "signs whereby we know the dwelling of the modern artist." Bonnard, Vuillard, Denis, and Redon all designed screens after Far Eastern prototypes.

Bonnard's four lithographed panels are inten-

tionally decorative and make striking use of terraced levels of figures receding in space and size and surrounded by empty areas in a manner typical of Japanese works of the same genre. Persuaded by the oriental rules of asymmetry, Bonnard set the focus of his composition at the far right with a light-footed company similar to such animated groups that appear in Ukiyo-e woodcuts. The strolling mother and children with toys might have been drawn from the cover of

69 PIERRE BONNARD   *Promenade of Nursemaids; Frieze of Horse Cabs. Color lithograph for a four-panel folding screen. 1897*

The Museum of Modern Art, New York. Mrs. John D. Rockefeller, Jr. Purchase Fund

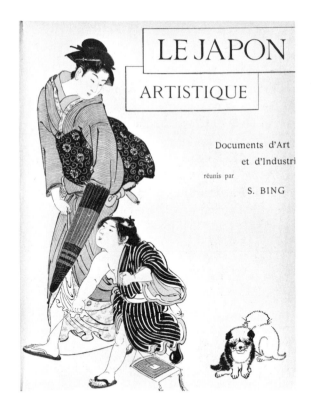

70 *Cover of* Le Japon Artistique, *February 1889,*
*reproducing a detail of a woodcut by Torii Kiyonaga*

The Metropolitan Museum of Art. Gift of Pierre L. Lebrun, 1922

*Le Japon Artistique* (70), where a portion of a print by Torii Kiyonaga appeared in February 1889.

The Japanese influence, always more apparent in Bonnard's prints than in his paintings (where the decorative effects come closer to the rich, ornamental crowding in tapestries or oriental rugs), fades from his art about 1900. Not yet thirty years old, Bonnard ceased designing luxurious, but generally unsaleable, color lithographs and turned his printmaking efforts to book illustration. At the same time, his painting style underwent a marked change. Stylized simplifications gave way to greater naturalism in modeling and narrative detail.

Japanese prints had broadened Bonnard's viewpoint and his palette. Their decisive role came in the early stages of his career when, sympathetic with his talent and temperament, they provided the catalyst to complete his emancipation from timeworn western rules. Even as his style evolved, flouting western conventions of color, form, and composition remained essential to Bonnard's achievement of intimacy and charm. Japanese prints helped him to that end.

1. The catalogue of the exhibition at the École des Beaux-Arts in 1890 lists over seventy prints and books by Utamaro. Edmond de Goncourt published his book on Utamaro in 1891.

2. Quoted in John Russell, *Edouard Vuillard, 1868–1940* (London, 1971), p. 24.

3. Bonnard could have seen approximately fifty prints by Harunobu at the École des Beaux-Arts in 1890.

4. Bernard Dorival, "Le Corsage à carreaux et les japonismes de Bonnard," *Revue du Louvre*, no. 1, 1969, pp. 21–24.

5. The catalogue of the exhibition at the École des Beaux-Arts in 1890 lists sixty entries for albums and prints by Hiroshige. In 1893 S. Bing organized an exhibition of over three hundred prints by Hiroshige and Utamaro at the Durand-Ruel Galleries.

6. Quoted by James Thrall Soby in *Bonnard and His Environment* (New York, 1964), p. 11.

7. A similar scene by Hiroshige from the *History of 47 Ronin* was reproduced in color in *Le Japon Artistique* for October 1888. See also Hokusai's Wooden Bridge in Tokyo, reproduced in Gonse, *L'Art Japonais,* 1883, vol. 1, p. 129, and Utamaro's Festival on the Sumida River, which appeared in color in the catalogue of the 1890 exhibition at the École des Beaux-Arts.

# Edouard Vuillard

The artists named most frequently in Vuillard's conversations were Corot, Puvis de Chavannes, and Delacroix. No one, it seems, remembers if he ever mentioned Hokusai, Hiroshige, or Harunobu, and we must wait until 1980, when his private journal can be made public, to learn if he ever made any observations on oriental art. Few writers on Vuillard have failed, however, to observe the influence of Japanese prints on his work.

Vuillard started his career with academic training of the most traditional kind. He visited museums regularly and admired the Old Master paintings, particularly those of Rembrandt, Vermeer, Chardin, and Le Sueur. However, his friends, the Nabis, were against traditional easel painting and in favor of a more decorative art. The Nabi credo that all art is basically decoration was pronounced by Maurice Denis in the well-known manifesto of 1890: "Remember that a picture, before being a battle horse, a female nude or some anecdote, is essentially a flat surface covered with colors assembled in a certain order." Japanese prints helped bring Vuillard to the same conclusion.

Vuillard, like Bonnard and Toulouse-Lautrec, achieved great artistic sophistication before the age of thirty. His most extraordinary panel paintings and color prints date from the 1890s. During that period Vuillard produced some fifty lithographs, roughly half of which were printed in color and attest to the profound role Ukiyo-e color woodcuts played in his early development.

Vuillard began the study of lithography during the winter of 1892–93 in the studio of the master printer Ancourt, where both Toulouse-Lautrec and Bonnard customarily worked. It could not have been long after Bonnard published his whimsical Family Scene (1893) (57) that Vuillard printed his equally simple and witty Seam-

67

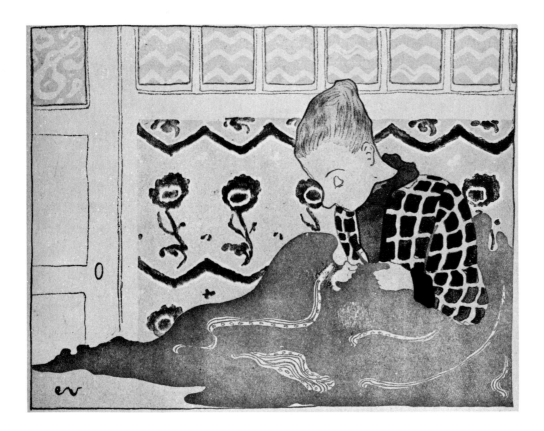

stress (*71*).[1] The snub-nosed ladies with down-
cast eyes and checkered blouses who appear in
both prints might have been drawn by the same
artist. Vuillard, who shared Bonnard's studio, his
views on art, and, on occasion, his caricatural
observation of the bourgeoisie,[2] chose as his
subject his tiny, round-faced mother, absorbed
in her tasks as a professional steamstress. She was
Vuillard's principal model (he called her his
"muse") until her death in 1928.

A sober bachelor who lived a narrow bourgeois
life, Vuillard never failed to take pleasure in the
insignificant everyday sights around him: the
methodical movements of his mother sewing,
reading, or cooking, surrounded by the comfort-
able furnishings of the apartment they shared. A
hush of tranquil domesticity settles on the scenes
and prompted André Gide to comment: "M.
Vuillard speaks almost in a whisper—as is only
right, when confidences are being exchanged—

and we have to bend over towards him to hear
what he says."[3]

The evocative, almost spiritual rendering of
daily life in much of Vuillard's art parallels the
intent of many Japanese prints, especially those
of Harunobu, which depict quiet interiors and
simple figures bathed in nostalgia and a vague
melancholy. Harunobu's woodcut of a youth
playing a drum (*72*), so similar in spirit to The
Seamstress, may have shown Vuillard the eco-
nomical but spellbinding way to set a solitary
figure in a shallow space. Vuillard's seamstress, as
modest and delicate as Harunobu's youth, com-
plements her ornamental surroundings. Her
gentle contours and the latticework she offsets
are embroidered in the pure lines, imaginative
patterns, and mix of tender greens and gray that
are Harunobu's trademarks.

Vuillard may have seen as many as fifty wood-
cuts by the Japanese printmaker in the exhibition

68

at the École des Beaux-Arts in 1890. Admired by artists and collectors, Harunobu was appreciatively characterized in the periodical *Le Japon Artistique* (December 1890) as "the painter of young girls and tender effusions."

Vuillard's print The Seamstress, though one of his earliest attempts at printmaking, is perhaps his most unusual in terms of technique, since it combines lithography with woodcut. Vuillard seems to have used separate woodengraved blocks to impress the flowered pattern and other portions of his design. In later prints he is known to have stamped patterns onto the lithographic stone with other carved woodblocks. Such methods of printing patterns may have been suggested by his grandfather or his uncle, both of whom were textile designers. Here Vuillard may have employed the woodcut technique to suggest Japanese printing methods.[4]

Vuillard's most important work as a print-

71 EDOUARD VUILLARD, 1868–1940

*The Seamstress. Color lithograph, wood-engraving, and woodcut. About 1893*

The Metropolitan Museum of Art. Elisha Whittelsey Fund, 1973.615

72 SUZUKI HARUNOBU, 1725–1770

*Youth playing a drum. Color woodcut. About 1768*

The Metropolitan Museum of Art. The H. O. Havemeyer Collection. Bequest of Mrs. H. O. Havemeyer, 1929. no. 1623

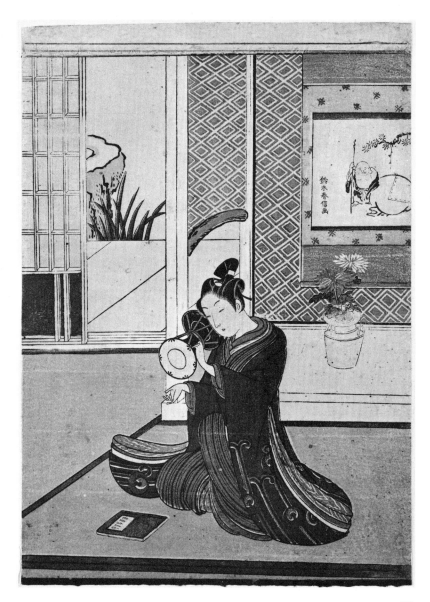

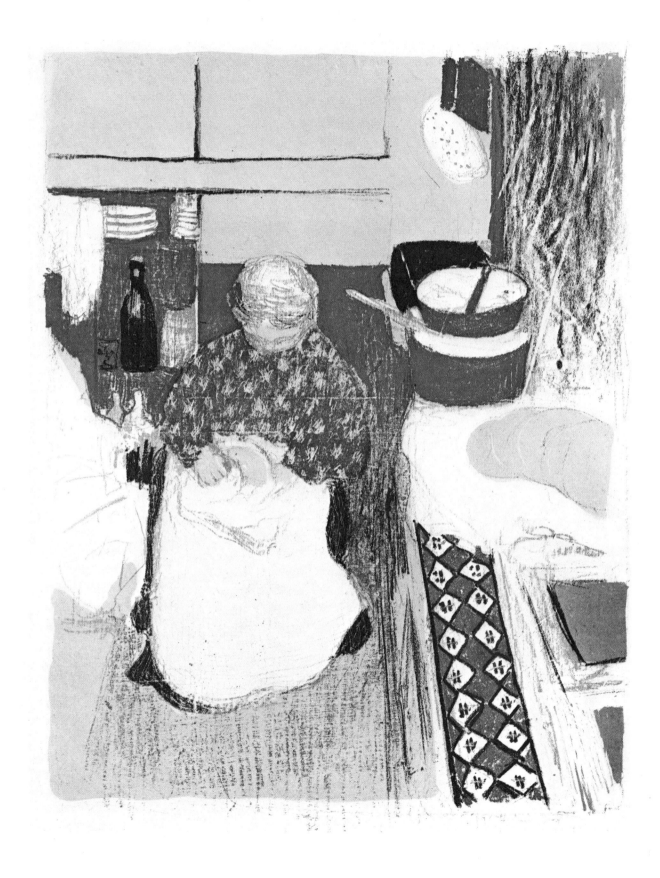

maker, the portfolio of twelve plates entitled *Landscapes and Interiors,* published by Ambroise Vollard in February 1899, parallels Bonnard's album *Aspects of Parisian Life,* published by Vollard the same year. Both sets of prints employ Japanese-style handling of Ukiyo-e subjects: scenes of contemporary life, at home (*73, 74*), in cafés, and on the boulevards. Unlike the early, experimental Seamstress, these lithographs are painterly and impressionistic in their handling, while they display the exceptional aptitude for the rhythmic and ornamental treatment of surfaces Vuillard developed in large decorative panel paintings between the years 1894–98.

The prominent role of decorative patterns in *Landscapes and Interiors* links Vuillard's prints to the Japanese, which rely on the sumptuous patterning of fabrics for much of their attractiveness. Vuillard, like so many Ukiyo-e printmakers, was part of the fabric-designing tradition. And though he was not, like some Japanese artists, skilled in textile handicrafts, his uncle the fabric designer and his mother the dressmaker had filled their apartment with the figured stuffs that prompted a confusion of patterns in Vuillard's work. The Japanese were similarly inspired by brocades, satins, and printed kimonos.

Treating his prints like swatches of cloth,

73 EDOUARD VUILLARD

*The Cook. Color lithograph from the series* Landscapes and Interiors. *1899*

The Metropolitan Museum of Art. Harris Brisbane Dick Fund, 25.70.17

74 YASHIMA GAKUTEI, active first half of 19th century

*A courtesan drinking tea. Color woodcut, surinomo*

The Metropolitan Museum of Art. Rogers Fund, 1919. no. 1139

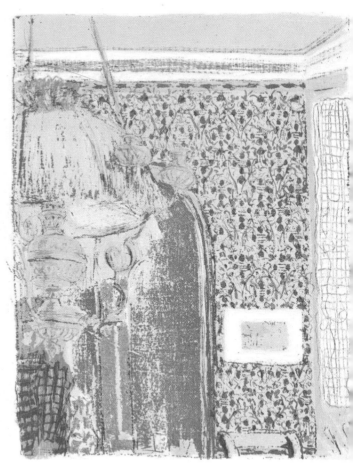

75 EDOUARD VUILLARD

*Interior with Pink Wallpaper I and II. Color lithographs from the series*
Landscapes and Interiors. *1899*

The Metropolitan Museum of Art. Harris Brisbane Dick Fund, 25.70.14, 19

Vuillard stamped them with tiny dots and hatches
in vibrating patterns that float across the surface
of the Interior with Pink Wallpaper I and II
(*75*), two prints that join as one in the manner
of Ukiyo-e diptychs. Here the overall picture is
a view of a cozy parlor seen from the middle
of the room before a suspended gaslamp. Vuillard
took a similar vantage point in his Interior with
a Hanging Lamp (*76*),[5] allowing the gaslight in
the upper corner to dominate the composition as
Hiroshige had the huge festival lantern strung to
the gateway of The Kinryūsan temple at
Asakūsa (*77*). Both lamps are ornamented, one

emblazoned with bold calligraphy, the other
sashed with dark ribbon. Additional parallels in
color, composition, and delicate overpatterning
suggest that Vuillard had Hiroshige's print in
mind, if not in his sketchbooks or actually before
him, when he drew the print. (His original draw-
ing on the lithographic stone, later reversed in
printing, would have made these resemblances
even clearer.)

It is not surprising that Vuillard chose
Hiroshige as his model. Hiroshige's *Views* were
collected by practically every connoisseur of
Japanese woodcuts and then, as now, his reputa-

tion as a master of landscape prints was surpassed only by Hokusai, after whom Vuillard modeled at least two other plates in his *Landscapes and Interiors* suite.

Hokusai's popular series, *Thirty-six Views of Mount Fuji* (1823–29), was, according to Edmond de Goncourt, whose biography of Hokusai was published in 1896, "the inspiration of Impressionist landscapes of the present day." Almost all the early *Views* were executed in the light blues, greens, and yellows that Vuillard favored. Their

76 EDOUARD VUILLARD

*Interior with a Hanging Lamp. Color lithograph from the series* Landscapes and Interiors. *1899*

The Metropolitan Museum of Art. Harris Brisbane Dick Fund, 25.70.23

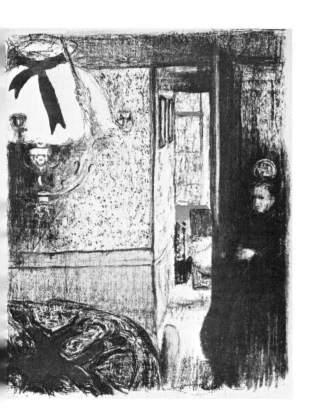

77 ANDŌ HIROSHIGE, 1791–1858

*The Kinryūsan temple at Asakūsa. Color woodcut from the series* One Hundred Famous Views of Edo. *1856–58*

The Metropolitan Museum of Art. Ex. coll. Howard Mansfield. Rogers Fund, 1936. no. 2519

78 KATSUSHIKA HOKUSAI, 1760–1849

*Fuji from the Sazaido, in the temple of the 500 Rakan, Edo. Color woodcut from the series* Thirty-six Views of Mount Fuji. *Late 1820s*

The Metropolitan Museum of Art. The Henry L. Phillips Collection. Bequest of Henry L. Phillips, 1940. no. 2984

79 EDOUARD VUILLARD

*Les Tuileries. Lithograph published in* L'Oeuvre, *1895*
Art Institute of Chicago

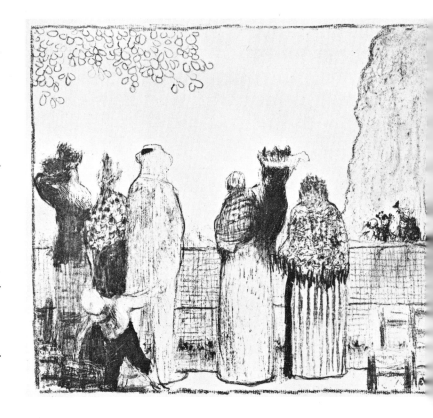

vigorous drawing, gentle humor, and eyecatching compositions must have appealed to his imagination as early as 1895, when he posed a group of Sunday strollers stopped before a fence in the Tuileries gardens in the same way Hokusai had shown sightseers leaning on a railing and gazing off at Fuji (*78, 79*).

Another of Hokusai's *Views* (*80*) may have inspired Vuillard's *Avenue* (*81*), a similar abstraction of reality compressed into carefully articulated planes like the "perspective prints" that became the vogue in Japan during the mid-eighteenth century, when ideas of western single-point perspective prompted exaggerated experiments. Both Hokusai and Vuillard consistently

74

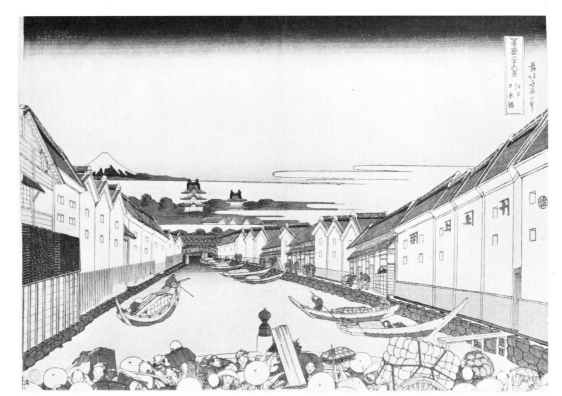

80 KATSUSHIKA HOKUSAI,
1760–1849

*View from the Nihon Bridge,*
*Edo. Color woodcut from the*
*series Thirty-six Views of*
Mount Fuji. *Late 1820s*

The Metropolitan Museum of Art.
Rogers Fund, 1922. no. 1295

81 EDOUARD VUILLARD

*The Avenue. Color lithograph*
*from the series* Landscapes
and Interiors. *1899*

The Metropolitan Museum of Art.
Harris Brisbane Dick Fund,
25.70.18

82 EDOUARD VUILLARD

*Across the Fields. Color lithograph from the series*
Landscapes and Interiors. *1899*

The Metropolitan Museum of Art. Harris Brisbane Dick Fund,
25.70.16

negated traditional foreground, middle ground,
and distance by using colors of equal intensity for
things both far and near. They structured the
surfaces of their prints with blocklike patterns
abstracted from rows of buildings and likewise
from patches of sunlight and shadow.

Vuillard relied on Hokusai to an even greater
extent in his color lithograph Across the Fields
(*82*). It is indebted to A gust of wind at Yejiri
from the *Thirty-six Views of Mount Fuji* (*83*)
for elements of composition and a harmony of

*A gust of wind at Yejiri, Suruga Province. Color woodcut from the series* Thirty-six Views of Mount Fuji. *Late 1820s*

The Metropolitan Museum of Art. Ex. coll. Howard Mansfield. Rogers Fund, 1936. no. 2553

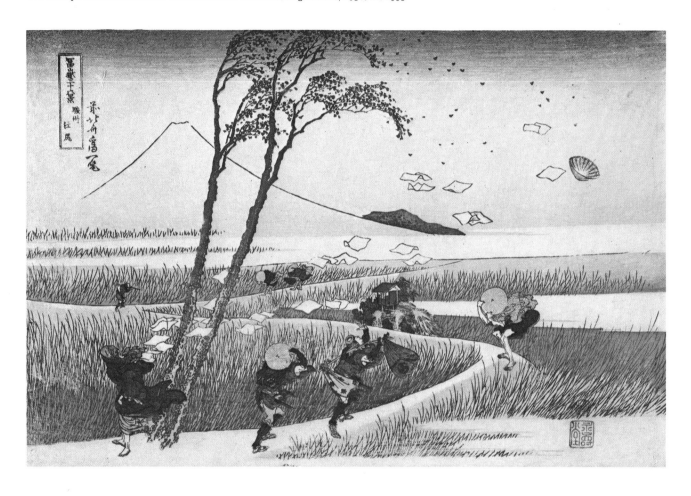

closely related colors. Both prints have a lyrical quality, though Hokusai's is characteristically more animated, more dynamically composed. The same brilliant artificial light seems to come from behind the pictures to silhouette figures, trees, and blades of grass. Vuillard, who worked from his sketchbooks, not from nature, interpreted landscape in terms as fantastic as Hokusai's and absorbed the human figures he drew into an unreal, ornamental world.

In 1901, only two years after the appearance of his *Landscapes and Interiors* suite, Vuillard published his last color prints. In the remaining thirty-nine years of his life, he drew less than a dozen lithographs and but a handful of etchings, all printed in black and white. The enthusiasm for color lithography and Japanese art faded from his work as it did from French fashion. The unnatural distortions of form and color were abandoned, and with them went the evocative symbolist and Ukiyo-e-inspired poetry that gave the early works such moody, self-conscious charm.

Japanese prints stimulated Vuillard's innate sensitivity to decorative pattern and the orchestration of color, presenting him with a sophisticated means of expressing his own natural bent. As a young artist exposed to the varied influences of Gauguin, Lautrec, Monet, Bonnard, and Degas, Vuillard admitted to Roger-Marx, "I hardly knew what I was aiming at." Of those early years when he wore a kimono and tacked Japanese prints to the walls of his studio, Vuillard recalled, "At that time, I was hunting in all directions."[6]

1. Previously uncatalogued, The Seamstress measures approximately 7½ x 10 inches. On the basis of style and signature and its association with Bonnard's color lithographs, it can be dated about 1893. Among related works are the color lithograph The Dressmaker, 1894 (Roger-Marx cat. no. 13) and the following paintings: Woman Mending (La Ravaudeuse), 1891, formerly in the collection of Thadée Natanson; Dressmaking (La Couture), 1892–95, in the collection of Mr. and Mrs. Hans Popper; and Woman Sewing, 1895, in the Museum of Fine Arts, Boston.

2. Vuillard's lively watercolor caricatures of the actor Coquelin Cadet, drawn in 1892, have been compared to the vigorous actor portraits Toshusai Sharaku produced a century earlier. They are strikingly close to the vivacious and economically handled Nō masks from Hokusai's *Manga,* which were reproduced in the French periodical *Le Japon Artistique* in August 1889.

3. André Gide, "A Walk Round the Salon d'Automne, 1905," *Gazette des Beaux-Arts,* December 1, 1905, translated in John Russell, *Edouard Vuillard, 1868–1940* (London, 1971).

4. The revival of interest in the woodcut medium was just beginning at this time, though there had long been a proliferation of more or less mechanical woodengravings as illustrations in periodicals. Gauguin is generally given credit for starting the so-called renaissance through the woodcuts he carved and engraved between 1893–95. However, Vuillard's friend and fellow Nabi Félix Vallotton had begun making woodcuts in 1891.

5. The unusual "snapshot" angles taken in these prints remind us that Vuillard was also a camera enthusiast.

6. Claude Roger-Marx, *Vuillard, His Life and Work* (New York, 1946), p. 49.

# Henri de Toulouse-Lautrec

Toulouse-Lautrec inherited a love of things foreign from his father, Count Alphonse the Second, who might sling a Japanese sword at his side while he sported a Buffalo Bill hat and a coat of mail. Henri too delighted in the trappings of other times and places. There are photographs of him disguised as a Pierrot and a choir boy; at least two camera portraits show him in Japanese daimyo robes.

The passion for exotic props extended beyond costume. It prompted the clutter that filled Lautrec's Montmartre apartment and was described by Arsène Alexandre in *Figaro Illustré* (April 1902) as tables "heaped with a miscellaneous collection of objects, each of which has some interest or association for [Lautrec].... He would fish out such odds and ends as a Japanese wig, a ballet slipper.... or else he would unexpectedly turn up, in this pile of debris, a fine Hokusai print."

Toulouse-Lautrec's enthusiasm for oriental art, and Japanese art in particular, developed early. Perhaps the first evidence of his interest occurs in a letter to his father dated April 17, 1882, in which he noted that the American painter Harry Humphrey Moore had shown him some "splendid Japanese bibelots." A year later, enchanted by the large exhibition of Japanese art at the Georges Petit Galleries, he began his own collection of Japanese prints and objets d'art.

In the studio of his painting instructor, Cormon, Lautrec shared his admiration for Japanese art with fellow pupils Louis Anquetin and Émile Bernard. He met van Gogh at Cormon's studio in 1886 and, at age twenty-two, just when his art began to mature, he studied the Japanese woodcuts on the walls of van Gogh's room at 54 rue Lepic.

The picture dealer and connoisseur of Japanese prints A. Portier lived in the same house as van Gogh. Lautrec often bought prints from him or, when he could persuade the dealer, traded his own paintings for color woodcuts by Hokusai, Hiroshige, Utamaro, Toyokuni, Kiyonaga, or Harunobu. (A photograph of about 1890 shows some of the Japanese prints Lautrec and his friend Henri Rachou bought and pasted to a screen in the home of Mme Ymart-Rachou, where Lautrec frequently dined.)

In 1891 Lautrec's friend Maurice Joyant succeeded Theo van Gogh as manager of the boulevard Montmartre branch of the Goupil Gallery. Thereafter Lautrec visited the shop almost daily to glance at the impressionist works exhibited there and to pore over the Japanese drawings and albums of prints that had been consigned to Joyant by the critic and Japanese enthusiast Théodore Duret.

Early visual evidence of Lautrec's fascination with Japanese things appears in his 1884 painting of the prostitute Fat Maria. A Japanese mask appears behind the model and could easily have been one hanging on a wall in the artist's studio. But Japanese art was more than a source of

colorful stage props. The Ukiyo-e prints he leafed
through at Portier's and Goupil's soon determined
the direction of Lautrec's personal style.

To begin with, Lautrec had a temperament and
a talent that would have been valued by the
Japanese: he was a keen observer and a brilliant
draughtsman. As a regular visitor to the café-
concerts in the district of his Montmartre studio,
he spent evenings on end studying and sketching
the exaggerated expressions and movements of
performers whose faces and figures were dis-
torted by theatrical make-up, the glare of stage
lights, and the audience's lowered angle of vision.
Degas and Ukiyo-e prints had opened his eyes to
the "modern" subjects of music halls, cafés, and
brothels, at the same time demonstrating uncon-
ventional means of handling the material.

By 1888 Lautrec had broken with his early
tight, impressionist manner to integrate his style
with the influences of Degas, van Gogh, and the
Japanese printmakers. He adopted a new idiom,
more spontaneous and economical, in which he
recorded what he saw swiftly and succinctly. The
principles of Japanese prints were unmistakable
in Lautrec's new style, which was based on cur-
vaceous forms, expressively outlined and filled in
with bright, flat colors that ignored western
principles of chiaroscuro modeling.

The direction toward flatness and simplicity
in Lautrec's work was further advanced by the
medium of color lithography, which he mastered
in 1891. The special demands of multicolor
lithography, which, like the technique of Japanese
color woodcuts, involves a separate block for
each color and a key block for the outlines,
required even greater conventionalization of
Lautrec's painterly technique. Moreover, the
smooth consistency of printed ink automatically
flattened and regularized his designs. Between
1891 and 1900 Lautrec made 362 lithographs, a
body of work distinct from his paintings, although
his simultaneous experiments in each medium
were mutually beneficial; each gave the other a
new identity.

Thirty of his lithographs were posters. In them
Lautrec explored the stylistic possibilities of the

85 HENRI DE TOULOUSE-LAUTREC,
1864–1901

*Aristide Bruant dans son cabaret. Color
lithograph, poster. 1893*

The Metropolitan Museum of Art. Harris
Brisbane Dick Fund, 32.88.17

Japanese idiom more fully than in any other aspect of his art. He recognized poster design as an art form in its own right, one well suited to the concise pictorial style of the Japanese print. The Japanese understood the impact of a simple, bold image and knew how to make calligraphy a compatible element in that design (*84*); Lautrec's poster for Aristide Bruant (*85*) demonstrates that he had mastered the lessons of Ukiyo-e. In

his very first poster, for the Moulin Rouge, the newly opened, gayest music hall in Paris, Lautrec revolutionized the art of poster design. He packed his lithograph with startling force, compelling colors, and bold composition. The result was the most vigorous and uncompromising poster on the walls of Paris.

The posters that followed were no less captivating. Those done between 1891 and 1893 to

86 HENRI DE TOULOUSE-LAUTREC

*Le Divan Japonais. Color lithograph, poster. 1893*

The Metropolitan Museum of Art. Harris Brisbane Dick Fund,
32.88.10

87 HENRI DE TOULOUSE-LAUTREC

*The Englishman at the Moulin Rouge. Color lithograph.
1892*

The Metropolitan Museum of Art. Gift of Mrs. Bessie Potter Vonnoh,
41.12.17

catch the atmosphere and mood of performers and patrons at the Moulin Rouge and the Divan Japonais are filled to the margins with large color shapes ornamentally outlined, some distinctly patterned with stripes or dots like the figured textiles in Ukiyo-e prints.

The Divan Japonais ("the Japanese settee") (*86*), a long and narrow café-concert on the rue des Martyrs, tried to capitalize on the fashionable oriental mode. Its walls were hung with bazaar-quality silks and fans; the waitresses dressed in kimonos. According to one of its stars, Yvette Guilbert, the audience was mostly painters, sculptors, and writers — "Brilliant Bohemia!" But it was the oppressive shabbiness of the place that struck Lautrec and reverberated in his 1892 poster showing Jane Avril, Edouard Dujardin, the music critic, and songstress Guilbert, her head unexpectedly lopped off by the top margin of the poster. Degas probably deserves credit for the unusual cropping, for the viol heads and conductor's arms waving from the orchestra pit, and for the prominent glare of the stage lighting. To Japan Lautrec owed the total effect of flatly colored masses and lively outlines combined in an airtight composition.

The jigsawed figure of Jane Avril seated at the bar compares with the arresting dark silhouettes Lautrec drew of regulars at the Moulin Rouge: the stiff-limbed dancer Valentin; bulky Môme Fromage, and the Englishman W. T. Warner seen blushing Kabuki-actor-style in the company of two Parisian "geishas" (*87*). Their figures are treated purely as decoration, flattened and abstracted, fitted into a composition held together by line. They exist in the narrow perspective of Japanese prints, where depth is described not by traditional modeling but solely by the relative sizes of the figures or by the slanting line of a floor.

Until the nineties French posters had relied almost completely on the primary colors. Lautrec's mastery of six or seven different lithographic stones for the layering of hues produced a range of purples, oranges, and greens which were not unusual in Japanese prints but to the Parisian eye were shocking. Taking his cue from the Japanese,

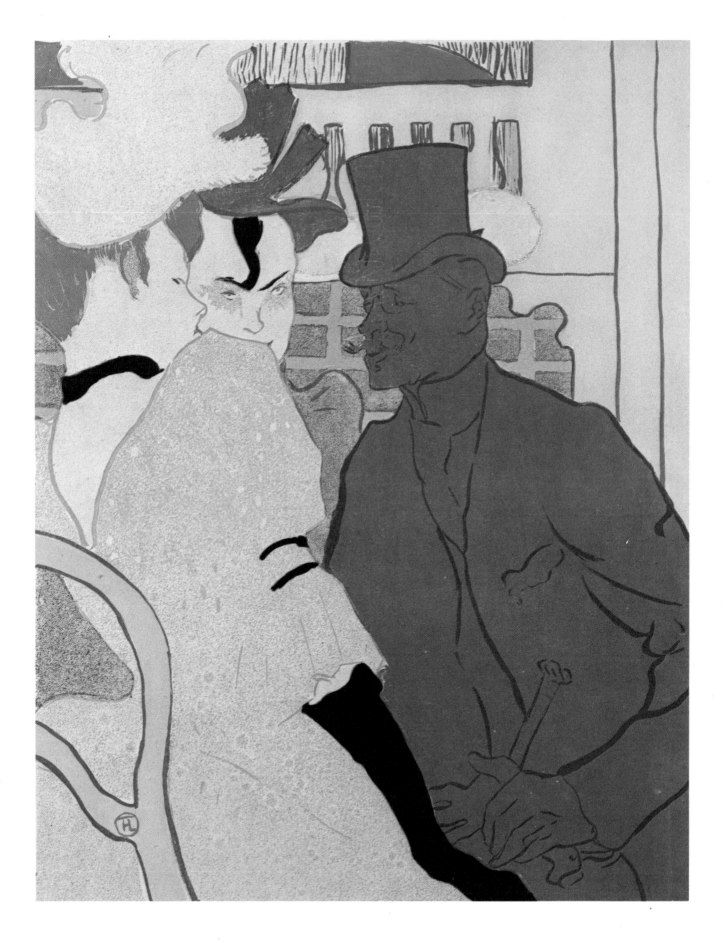

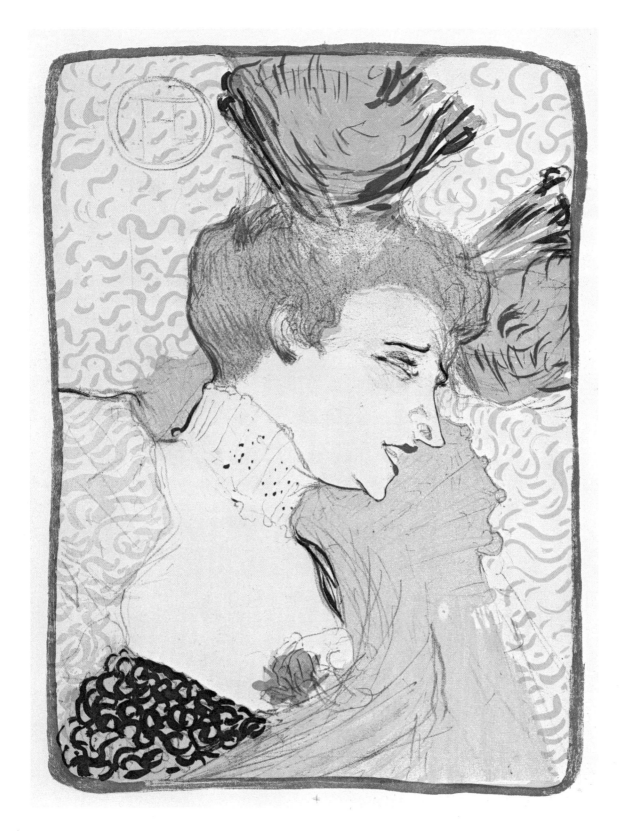

**88 HENRI DE TOULOUSE-LAUTREC**

*Mlle Marcelle Lender en buste. Color lithograph. 1895*

The Metropolitan Museum of Art. Alfred Stieglitz Collection, 49.55.183

**89 KITAGAWA UTAMARO, 1753–1806**

*A courtesan. Color woodcut*

The Metropolitan Museum of Art. The H. O. Havemeyer Collection.
Bequest of Mrs. H. O. Havemeyer, 1929. no. 1663

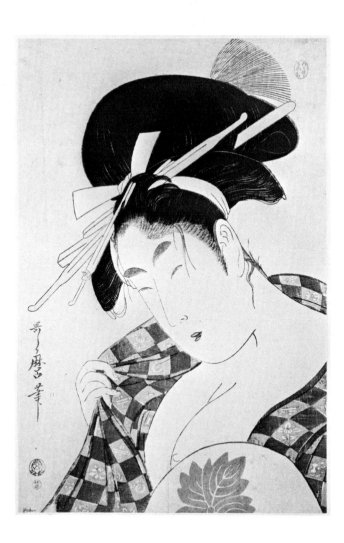

Lautrec chose his unusual and highly charged color combinations to function as decoration, rather than as realistic description. Though, not by accident, the aniline mauves, citrons, and darkest black express the artificial, often sordid mood of Montmartre night life.

Lautrec's earliest posters are signed "T-Lautrec," but sometime in 1892 he began to use as his signature a circle enclosing the monogram "HTL." The new monogram surely derived from the circular seals Japanese artists and publishers applied to their prints and which Lautrec had spent days and evenings at Goupil's learning to read and reproduce. Lautrec used the monogram consistently in prints from 1892 onward, sometimes playfully enclosing it in the silhouette of a teapot, a mouse, or an elephant. (On a menu he designed for May Belfort in 1896, he drew the monogram as a mouse hole, into which a little black mouse, pursued by a cat, was seen to hurry.) The monogram appears less frequently in paintings: Lautrec seems to have associated it with printing. He also used it as his studio stamp (cachet), and after his death many of his works were stamped with the same mark.

Occasionally Lautrec had his monogram printed in red ink, as the Japanese did. Generally, as in his posters for the Moulin Rouge, he placed it in a lower corner. The most conspicuous treatment of the monogram appears in the sumptuous eight-color lithograph of Marcelle Lender (1895) (*88*). A prominent motif in the upper left corner, Lautrec's sign heightens the strong Japanese flavor of the print. The pale geishalike profile of Mlle Lender and the references to the brocades, kimonos, and stylish coiffures of Japan are drawn directly from color woodcuts of courtesans by Kitagawa Utamaro (*89*)—as is the format, resembling the bust portraits that became fashionable in Japan about 1790.

Lautrec's early lithographs (through 1893) show his preference for lithographic ink over the sketchier crayon, which he used with greater regularity later. The fluid outlines that describe the colored forms in his posters are a kind of decoration in themselves, like the vital, winding

line of art nouveau. They are akin to the black key block lines in Japanese woodcuts, and are even closer in character to brushstrokes in Japanese ink drawings.

Lautrec, who had ordered a Japanese ink stone, *sumi* stick, and brushes especially from Japan, practiced his draughtsmanship by drawing little inkbrush sketches in the manner of Hokusai. Like the oriental masters, he trained his brush to invent lively little figures with a few highly expressive lines. If such sketches were thought bizarre by his contemporaries, they were explained easily enough by the critic Arsène Alexandre, who declared: "The drawings of a madman? These are the drawings of a madman, indeed, but only in the sense in which Hokusai used the term when he called himself 'the old man mad about drawing.'"

Lautrec captured Jane Avril's fluttering steps in a mobile linear design. For Loie Fuller (*90*), whose "fire dance" was a spectacular hit at the Folies Bergère, he devised a billowing cloud seen through a fog of smoke and light. Miss Fuller's act, like the "lion dance" in Japanese prints, depended upon the artful manipulation of voluminous skirts which, cleverly plied, seemed to exist quite independently of the performer. However successful the effect of her dance, Loie Fuller was dismayed at her portrayal as merely an appendage to her costume. In fact, Lautrec's depiction of her is so unusual and daring, so foreign to anything in western art up to that time (and but a step away from twentieth-century abstract art) that the concept could only have come from the Japanese[1] ... from their images of actors and tiny court ladies enveloped in layers of ceremonial robes, as pictured in woodcuts (*91*), paintings, and in black and gold lacquers. Surely the inspiration to add genuine gold to the print came from the Japanese, who sometimes enriched their color prints with a sprinkling of mica or powdered brass dust. Lautrec applied gold with cotton pads to each of fifty impressions of his lithograph to give brilliance to the image and to recreate Miss Fuller's spectacular stage effects, which boasted the very first electric footlights.

90 HENRI DE TOULOUSE-LAUTREC

*Miss Loie Fuller. Color lithograph. 1893*

The Metropolitan Museum of Art. Rogers Fund, 1970.534

91 DANJURO VII, 1791–1859

*Danjuro (?) in a* shibaraku *role. Color woodcut with mica and brass powder applied, surinomo*

The Metropolitan Museum of Art. Rogers Fund, 1922. no. 1301

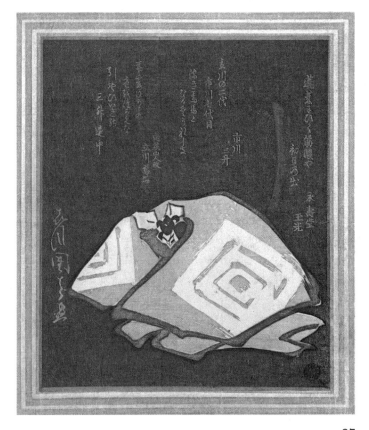

92 HENRI DE TOULOUSE-LAUTREC

*Jane Avril. Lithograph from the series* Café-Concert. *1893*

The Metropolitan Museum of Art. Harris Brisbane Dick Fund, 23.30.3(1)

Lautrec was probably the first European painter to fully recognize the power of the Japanese brush line. His black and white lithograph of Jane Avril (*92*), drawn in 1893, illustrates better than any other his mastery of the undulating line, alternately thick and thin. Here it is swept along as independent linear decoration, simultaneously expressing the flouncing of Mlle Avril's skirts.

Lautrec seems to have been fascinated with dancers' skirts as both ornamental design and vehicles of movement. In 1891 he made the petticoats of La Goulue the focal point of his Moulin Rouge poster. In 1892, in two amusing sketches, he drew the swirling veils of ballerinas leaping from waterlily to waterlily in a burlesque version of a Japanese ballet called the *Ballet de Papa Chrysanthème*. In 1893 Lautrec drew his important lithographs of dancers Jane Avril and Loie Fuller enveloped by their skirts. In many ways these prints are equivalent to those by Torii Kiyotada (*93*) and Shunkō, which depict Kabuki actors suspended in motion, midway through the violent dances of their *aragoto* ("rough stuff") roles. In the Japanese prints, as in Lautrec's, the motion of the dance is caught still, as if by a camera. The dancers' costumes are seen whipped about, overwhelming their wearers to the extent that only heads and feet are visible beyond the turbulent cloth.

Directly or indirectly, pictures of people were Lautrec's lifework. His witty characterizations of the demimonde of turn-of-the-century Paris are the great power behind his posters and litho-

94 TŌSHŪSAI SHARAKU, active 1794–1795

*The actor Otani Oniji III as Edohei. Color woodcut, mica ground*

The Metropolitan Museum of Art. The Henry L. Phillips Collection. Bequest of Henry L. Phillips, 1940. no. 2

95 HENRI DE TOULOUSE-LAUTREC

*At the Moulin Rouge: La Goulou and La Môme Fromage. Color lithograph. 1892*

The Metropolitan Museum of Art. Gift of Mrs. Bessie Potter Vonnoh, 41.12.18

graphs. His portraits of actors reveal piercing insights into individual character and, combined as they are with a superb decorative sense, compare with those produced between 1794–95 by the daring Kabuki artist Sharaku (*94*).

The trend toward realism in eighteenth-century Japanese theater prints reached its zenith with Sharaku, who showed actors as individuals, not sterile stereotypes. For a time an actor himself, Sharaku made posters and advertisements for the popular Kabuki theater. Instead of concentrating on the role the actor was playing, Sharaku pene-

trated the theatrical mask to reveal sometimes frightening, all too human qualities of lust or greed.

Sharaku simplified and distorted the faces of his subjects unmercifully. Disturbing as they were, the dynamic effects he created must have impressed Lautrec who, forever probing the personalities of his subjects, frequently adopted Sharaku's forceful approach. Studying the music-hall character La Môme Fromage (*95*), Lautrec described her with the lurid grimace and theatrical make-up of one of Sharaku's Kabuki actors.

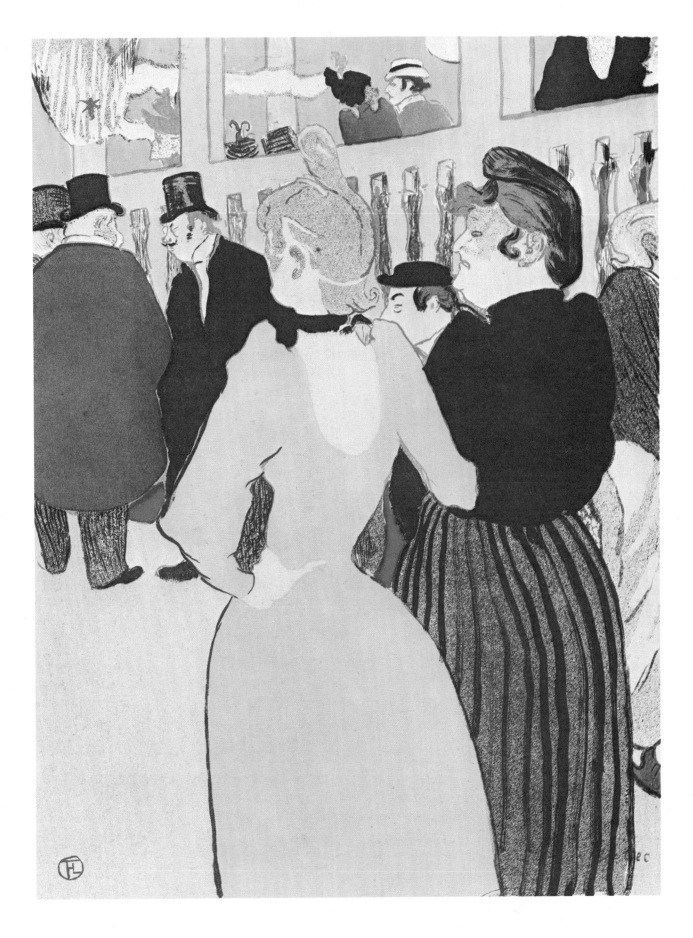

96 HENRI DE TOULOUSE-LAUTREC    *Yvette Guilbert singing "Linger, Longer, Loo." Color lithograph from a series of eight.*
*1898*

The Metropolitan Museum of Art. Gift of Mrs. H. Wolf, 17.52(9)

Critics of both Sharaku and Lautrec complained that the bizarrely exaggerated faces in their posters made them repulsive. Yvette Guilbert (*96*), on whom Lautrec lavished his attention in twenty-nine prints, pleaded with him: "For heaven's sake, don't make me so horribly ugly! A little less, please. . . . Lots of people who have been here have screamed out loud when they saw the design for the poster."

Two albums of lithographs of Yvette Guilbert, one of sixteen plates (1894), the other of eight (1898), exhibit the extent to which Lautrec concentrated on a single personality and revealed it as theatrical experience. It was Lautrec's custom, as it was among the Japanese, always to fix the performer in a characteristic pose.[2] Thus Mlle Guilbert is shown in a series of unforgettable attitudes and expressions that are uniquely hers. She is caught in the midst of her act, her trademark—lanky black-gloved arms—dramatically poised, her chin thrust out to punctuate some bawdy song. Her jeering expression, the disproportionate nose and thin, wry smile are inherited from Sharaku's unforgettable portraits (*97*). In startling close-up and a harsh, unforgiving light, she assumes the same monumental, comic grandeur.

In his series *Elles* (1896) Lautrec concentrated on the diversity and expressiveness of the human body. He used as the principal subject of his set of eleven lithographs the everyday life of Parisian prostitutes, a somewhat daring subject for "fine" art at that time. Degas had treated prostitutes in brothel settings in monotypes around 1880. Lautrec knew Degas's pictures, admired them greatly, and certainly shared Degas's appreciation of Japanese prints of similar subjects.

Lautrec was known to be especially fond of erotic Japanese prints ("shunga") and owned a copy of Utamaro's notorious album *The Poem of the Pillow,* which he got from the Goncourt brothers. His *Elles* series in many ways parallels another set of prints by Utamaro, the twelve woodcuts of courtesans that comprised *The Twelve Hours of the Green Houses* (about 1795), which Edmond de Goncourt in his volume on

Utamaro (1891) judged the loveliest of the Japanese master's print series.[3]

Lautrec followed Utamaro by actually moving into the "green houses" where he observed the women bathing, dressing, combing their hair. Like Utamaro's prostitutes, Lautrec's *Elles* are apt to look bored or embittered. But Lautrec understood the basic differences between carefully trained, educated geishas and Parisian prostitutes; he did not try to imitate Utamaro's ideal, elegant

97 TŌSHŪSAI SHARAKU, active 1794–1795

*The actor Sakata Hangoro III as Fujikawa Mizuyemon. Color woodcut, mica ground*

The Metropolitan Museum of Art. Fletcher Fund, 1929. no. 1522

courtesans with swanlike necks and elaborate coiffures, but drew his own models with a reportorial accuracy that—without moral outrage or lust—described their lives.

Lautrec may have been alluding to the orientalism of his subject and its treatment by using as the first plate of *Elles* the clownesse from the Moulin Rouge who had changed her name from "Chahut-Chaos" (a description of her acrobatic dancing act) to the more oriental, and therefore more fashionable, "Cha-U-Kao" (98). She is unexpectedly posed like one of Hokusai's nimble acrobats, her silhouetted arms and legs interlocked in a splendid example of the Japanese arabesque. She occupies a space ruled by Japanese perspective: the floor tilted up, the background defined by strips of color. The spattered "crachis" recreate the glittering surfaces of Utamaro's prints, which were sometimes sprinkled with brass powder over yellow grounds.

The luscious pinks and yellows of the Clownesse and elsewhere in *Elles* were probably also inspired by Utamaro's woodcuts, which Lautrec was said to admire for their colors. Japanese prints frequently prompted unusual combinations of bold, harsh colors in Lautrec's posters, but, as Joyant observed, Utamaro's Yoshiwara albums gave him a range of subtle Japanese colors such as "eggplant white and fishbelly white," "rosy snow and bluish snow," "heart of onion green, tea green and crab green."

His friend Gauzi said that Lautrec considered the Japanese his "brothers"; they were closer to his dwarfed size, and beside them he looked normal. All his life he longed to sail to Japan, but he consistently failed to convince a friend to join him, turned down his mother's offer to pay his way, and never did make the trip.

An enthusiasm for Japanese art is apparent throughout Lautrec's short but active career as a printmaker. The high point of his *japonisme* is clearly the period of his outstanding poster production (1891–93), but a still strong, continuing sympathy with Japanese art is evident in his illustrations for Jules Renard's *Histoires Naturelles,* done in 1899, in which the spider, frog, and

snail in particular are described with an oriental economy and respect for the white of the page.

In both how he made his prints and what he put in them Lautrec learned from the Japanese. He shared with them a fascination for the burlesque in daily life and admired its forceful portrayal in the prints of Sharaku and Utamaro. But unlike the Japanese, Lautrec explored the diversity of individual faces and figures, which he frequently described in a loose, organic manner that suggests his affinity with Daumier. Lautrec, who was inspired by the overall formal effects of the Japanese woodcut—its color, line, and patterning—fortuitously recognized a graphic character close to his own temperament and perfectly suited to the lithographic medium. No other western artist so completely adopted the Japanese woodcut for his own purposes.

98 HENRI DE TOULOUSE-LAUTREC

*The Seated Clownesse. Color lithograph from the series* Elles. *1896*

The Metropolitan Museum of Art. Alfred Stieglitz Collection, 49.55.50

1. In an article titled "Japonisme d'Art" in *Figaro Illustré,* April 1893 (the same year Lautrec produced his lithograph of Loie Fuller), "C.D." (Carolus-Duran?) praised the Japanese for their ability to represent the human body in motion and compared the animation of their pictures to Loie Fuller's dance. The article is illustrated with an unidentified Japanese print of a turbulent dancer, one similar to the gold-tinted pictures Bing had published in *Le Japon Artistique* in 1889. (Issue no. 13 had contained a kakemono by Tisuo [?]; no. 18 included a surimono by Hokkei.)

2. The stylized postures in which Yvette Guilbert is depicted full-length (for example, plate 4 in Lautrec's 1894 album, Delteil no. 83) compare with those of the Kabuki players Shunshō depicted in theatrical *mie,* the sustained pose in which an actor froze, his eyes crossed, his stance foreboding.

3. There are certain figures in Utamaro's *The Twelve Hours of the Green Houses* Lautrec may have copied for *Elles* (for example, the woman bent over, seen from behind, in The Hour of the Cock, who corresponds to the woman pouring water from a basin in Lautrec's *Femme au Tub* [Delteil no. 183]).

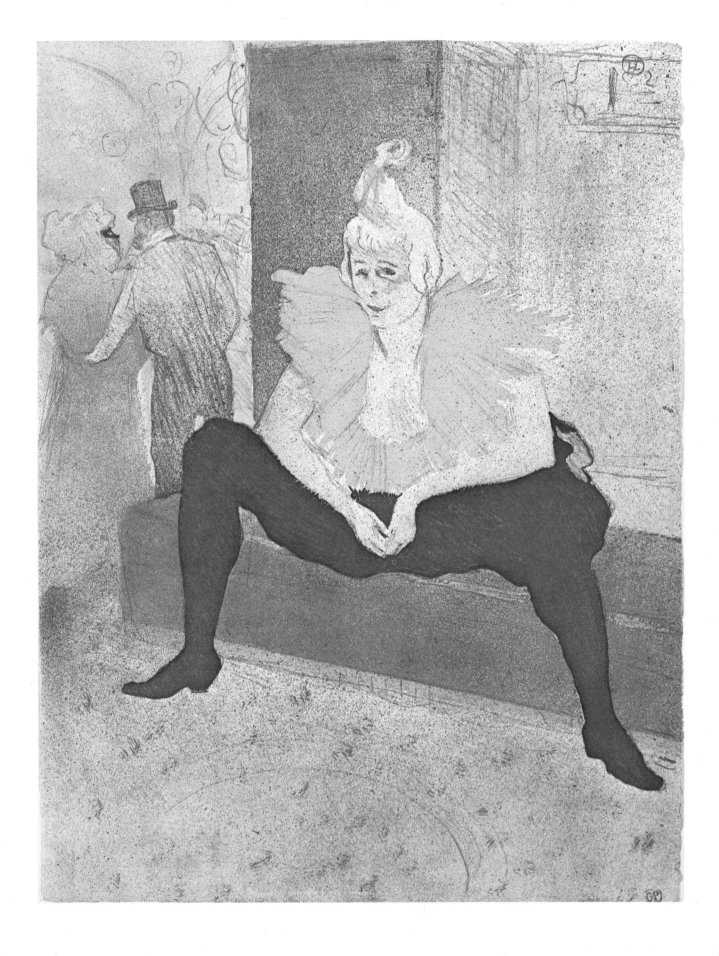

# Paul Gauguin

Exotic places and primitive peoples were always part of Paul Gauguin's life. When he was only a child he emigrated with his parents to Peru; as a young sailor he visited the ports of Rio de Janeiro and Bahia; and when he began painting seriously he hunted for the last outposts of primitive naturalism. His quest led him to Brittany in France, Panama, and the island of Martinique; Escaping ever farther, he voyaged twice to Tahiti (in 1891 and again in 1895) and ended his days in the comparative wilderness of the Marquesas.

"Have always before you the Persians, the Cambodians and a bit of the Egyptian," Gauguin advised Daniel de Monfreid in a letter from Tahiti in October 1897.[1] He might well have added "and prints by the Japanese," for Ukiyo-e woodcuts went with him wherever he traveled as part of his portable museum. At Pont-Aven in 1888 Gauguin's studio atop the Pension Gloanec was decorated with prints by Utamaro; the immense attic he painted in at Le Pouldu two years later was also hung with Ukiyo-e; and between his trips to Brittany his Paris studio was an unofficial gallery of Japanese drawings and "a sort of frieze made of prints by Hokusai and Utamaro."[2] The Ukiyo-e woodcuts that sailed with him to the South Seas as part of his reference collection were noted in his journal, *Avant et Après*:[3] "In my hut there are all sorts of odds and ends that appear extraordinary because here they are unusual: Japanese prints, photographs of pictures, Manet, Puvis de Chavannes, Degas, Rembrandt, Raphael, Michael Angelo." After his death in 1903 the inventory of Gauguin's meager possessions included a Japanese sword, a Japanese book, and forty-five prints tacked to the walls of his dwelling, some of them, undoubtedly, Japanese.[4]

Gauguin became the first major artist to recognize the esthetic merits in the arts of "primitive" peoples. His admiration was so complete that he modeled his own art on many of the characteristic modes and motives of neglected arts and crafts from the far reaches of South America and Asia, including China, Egypt, India, and Java. Gauguin's interest in Japanese art was probably awakened by Degas and the impressionists. As early as 1884 he carved a small box with pictures of ballet dancers and copies of Japanese netsuke,[5] and in 1885 he painted a still life that included a Japanese puppet as well as several fans. In 1888 and 1889 Gauguin's enthusiasm for Ukiyo-e woodcuts emerged. Japanese prints appear in the background of his painting Apples and Vase, and in his Portrait of the Schuffenecker Family and, most prominently, in the luxuriant Still Life with Head-shaped Vase and Japanese Woodcut (99), in which Gauguin's own rugged profile is comrade to an Ukiyo-e portrait of an actor.[6]

A sudden break in Gauguin's artistic development signaled his growing admiration for the principles underlying Japanese woodcuts; during the summer of 1888 he produced several paintings in a new "synthetic style" that reduced everything to simple color shapes and broad outlines. One of the first important paintings that demonstrates the Japanizing turn, The Vision after the Sermon (1888), owes its wrestling Jacob and angel to figures in Hokusai's *Manga*. Gauguin described his own composition as "quite Japanese, by a savage from Peru."[7]

Among the decisive influences upon Gauguin at this moment were his friendship with Ukiyo-e enthusiast Émile Bernard, whom he met in 1886 and his simultaneous discovery of the historic

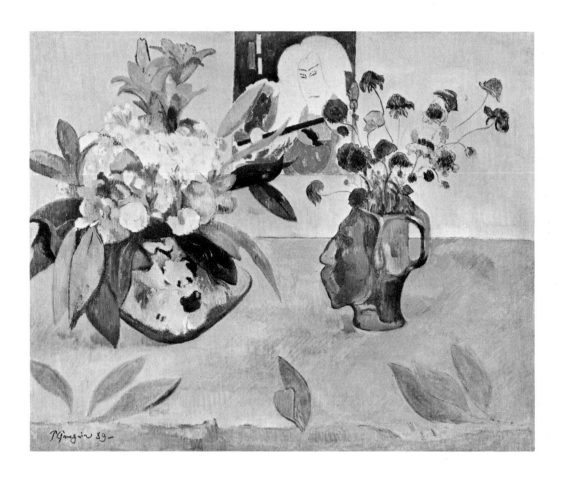

99 PAUL GAUGUIN, 1848–1903

*Still Life with Head-shaped Vase and Japanese Woodcut. Oil on canvas. 1889*

Aquavella Galleries, Inc., New York

arts of Brittany: Romanesque sculpture and stained glass, which, like Japanese woodcuts, were marked by flat planes and strong outlines. The exhibition of Japanese prints organized by the art dealer S. Bing in Paris in the spring of 1888 may also have been persuasive.

In 1889 Gauguin finished a series of eleven lithographs drawn on zinc, interpretations of paintings inspired by his trips to Pont-Aven, Arles, and Martinique. As he translated his paintings into a graphic medium, Gauguin pressed his compositions into even more stylized and abstract terms, and the extent of his reliance on Japanese principles of design became clearer. There is less

indication of atmosphere, practically no modeling, and a greater flattening of perspective in these zincographs. Whatever descriptive colors existed in the paintings were replaced by a strictly decorative play of black ink against a brilliant background of saffron yellow. Gauguin's surprising choice of yellow paper might have been prompted by any number of Japanese prints and book illustrations in his own collection or, for that matter, in that of van Gogh, with whom he stayed in 1888. Japanese ink drawings and prints on bright yellow paper could be seen reproduced in current French books and periodicals such as *Le Japon Artistique.*

**100** PAUL GAUGUIN

*Leda. Lithograph on zinc, printed on yellow paper and heightened with watercolor, from a series of eleven. 1889*

The Metropolitan Museum of Art. Rogers Fund, 22.82.2-1

**101** UTAGAWA KUNIYOSHI

*O Kane, a strong woman from Omi Province. Color woodcut. About 1843–47*

The Raymond A. Bidwell Collection of Prints. Museum of Fine Arts, Springfield, Massachusetts

**102** PAUL GAUGUIN

*Pleasures of Brittany. Lithograph on zinc, printed on yellow paper, from a series of eleven. 1889*

The Metropolitan Museum of Art. Rogers Fund, 22.82.2-11

Gauguin established an oriental note in his zincograph portfolio by placing a fragile, flower-trimmed Leda (*100*) on the cover; the circular format and the delicate hand coloring derive from Ukiyo-e portrait prints (*101*). Gauguin's simple decorative arrangement of flattened forms and curvaceous outlines acknowledges Japanese art while reflecting as well the naïve simplicity he admired of Breton peasant girls.

While van Gogh declared he had discovered "Japan" in the sunny south of France, Gauguin apparently found it in the north. His pastoral Pleasures of Brittany (*102*) recalls the gently rolling terrain, clear light, and tranquil pastimes that epitomize Japan in prints by Harunobu (*103*). Describing Breton sights in Ukiyo-e terms, Gauguin reduced the landscape to a simply described plane rising sharply from the foreground and focused attention on the silhouettes of two strolling girls, decoratively arrayed in

103 SUZUKI HARUNOBU, 1725–1770

*A young woman attended by a maid, near a stream and touching a branch of blossoming bush clover. Color woodcut*

The Metropolitan Museum of Art. Ex. coll. Howard Mansfield. Rogers Fund, 1936. no. 2442

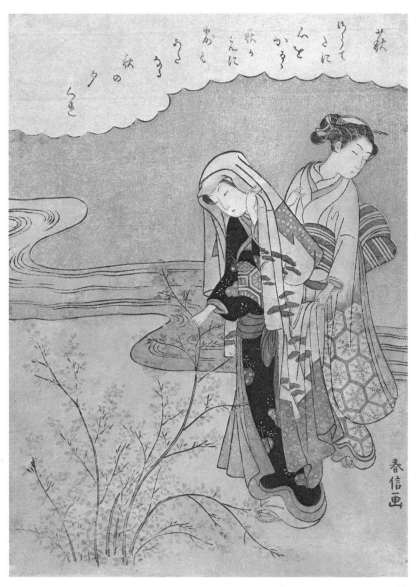

*Women Washing. Lithograph on zinc, printed on yellow*
*paper, from a series of eleven. 1889*

The Metropolitan Museum of Art. Rogers Fund, 22. 82.2-8

native costume. References to sunlight and shadow were abandoned according to oriental custom. In 1888 Gauguin wrote: "Look at the Japanese who draw so admirably and you will see there life in the open air and in the sun without shadows..."[8]

Evidence of his further fascination with Japanese mannerisms, Gauguin also adopted oriental stylizations for water currents and the

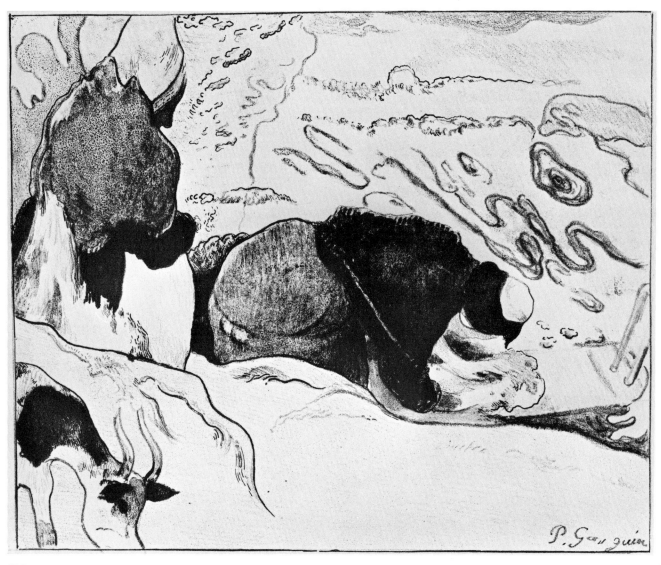

sea. His painting The Wave (1888), thought to have been inspired by Hiroshige's print The Whirlpools of Awa, indicates Gauguin's familiarity with Japanese woodcuts that treated tossed waves and surf in abstract terms. From 1888 onward, Gauguin followed the Japanese woodcut artists' curvilinear notations in almost every aspect of his land- and seascapes. In his print of Breton Women Washing (104) he silhouetted the

two foreground figures against a backdrop of ripples and whirlpools. The arrangement of condensed decorative shapes is indebted to Ukiyo-e design principles and is possibly a direct interpretation of a seaside scene from The Flowering *Katsura* of Harunobu (105).

Gauguin's readiness to refer explicitly to the Japanese sources for his prints is evident in his illustration of Edgar Allan Poe's story "A Descent

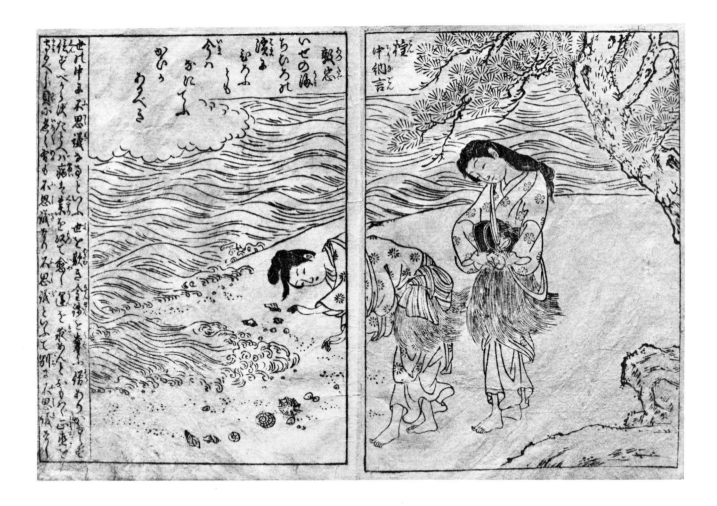

105 SUZUKI HARUNOBU, 1725–1770

*Gathering seashells on the beach. Illustration in the picture book The Flowering* Katsura. *Woodcut. 1764*

Jack Hillier Collection

into the Maelstrom" (*106*). This Brittany-inspired seascape is based pictorially on Sadahide's color woodcut of a seaweed gatherer (*107*). Gauguin retained the essential format of the Japanese fan print but cleverly inverted its curved shape to suggest a whirlpool's sloping walls. In Gauguin's picture, as in Sadahide's, a tiny protagonist is threatened by dark waters, vigorously drawn.

Shortly after exhibiting his series of zincographs at the Universal Exposition of 1889, Gauguin made up his mind to flee the stifling atmosphere of overdeveloped Europe. Sparked by the exotic sights (particularly the Asian pavilions)

at the Exposition, Gauguin determined to escape to French Indochina. In 1890 he wrote to Émile Bernard: "The entire Orient—its lofty thought inscribed in gold letters in all its art—is well worth studying, and I believe that I shall find renewed strength there. The West is decadent now, but everything that is Herculean can, like Anteus, gain new power by touching the soil of the East."[9] However, after failing to obtain a paying government post in Tonkin, Gauguin was forced to consider alternative retreats, and he finally set sail for Tahiti in 1891 at the age of forty-three.

Though it was not the Orient he had earlier dreamed of, nor was it as unsettled as he had

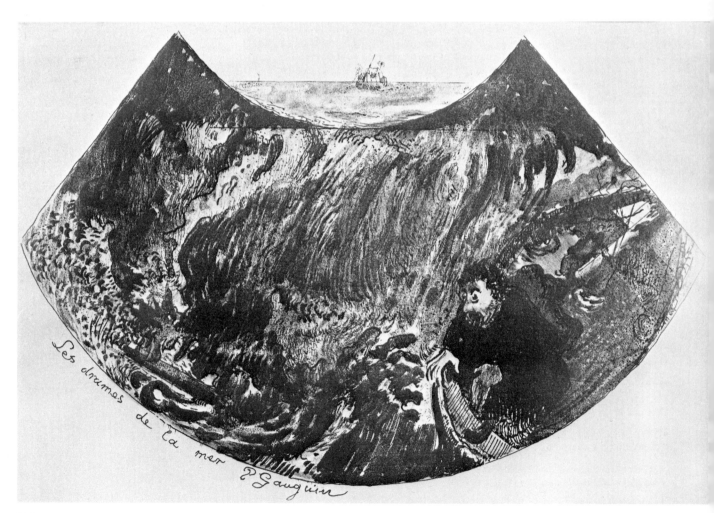

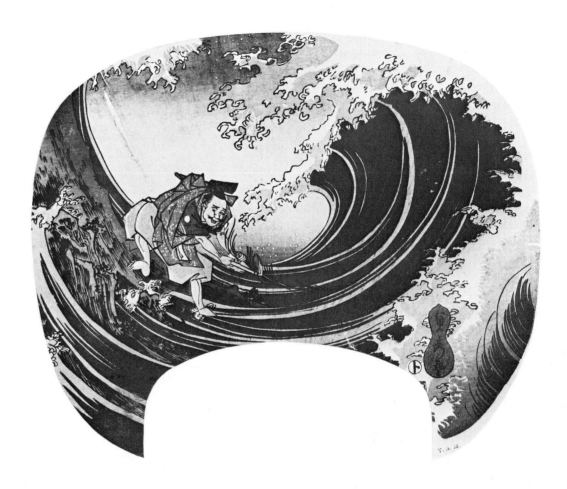

hoped, Tahiti provided an exotic atmosphere for his reflections on primitive art. Tahiti supplied Gauguin with native models and tropical vegetation, but his painting style did not alter radically with island life. Its sources were still deeply rooted in the arts of Egypt, India, Java, and Japan.

On his return to France in 1893 Gauguin produced a suite of ten woodcuts to illustrate a romanticized journal of his Tahitian sojourn, *Noa Noa* (Oh, Fragrant Earth). These prints are among the most primitive looking of his works and in both subject and technique represent a culmination of his identification with Asian art. The themes and figures are drawn from earlier paintings (most done during the Tahitian stay of 1891–93), but the process of printing by hand from crudely carved and colored blocks was new to Gauguin, as it was to contemporary printmaking practices.[10] Here Gauguin attempted to

107 SADAHIDE

*The Seaweed gatherer. Color woodcut, fan print. About 1850*

Victoria and Albert Museum, London

106 (OPPOSITE PAGE) PAUL GAUGUIN

*Dramas of the Sea: A Descent into the Maelstrom. Lithograph on zinc, printed on yellow paper, from a series of eleven. 1889*

The Metropolitan Museum of Art. Rogers Fund, 22.82.2-7

imitate the earliest, most primitive forms of printmaking, probably the schematic incunabula of Japanese woodcuts. Later, in a letter to de Monfreid (August 1901), whom he had entrusted with many of his works, Gauguin wrote:

> Sometime after you sell something I wish you would keep out one or two hundred francs and have some of the wood-prints well-framed. . . It is because these prints go back to the most primitive time of engraving that they are interesting. Wood-engraving for illustrations has become like photogravure, sickening. . . I am sure that in time my wood-engravings, which are so different from all the engraving done now, will have a certain value.

The title plate to *Noa Noa* (*108*) illustrates the technique Gauguin learned from early Japanese prints and employed throughout his woodcut set. It is characterized by sharply contrasting areas of black and white, with broad expanses enlivened by linear pattern. The prominent use of white lines for defining and detailing forms may draw on the relief processes employed in some early Ukiyo-e woodcuts in which white lines figured on black grounds in imitation of stone rubbings (*109*). Such "primitive" Japanese prints were known and appreciated by French art critics and collectors during Gauguin's time and, if we may judge from Théodore Duret's remarks in the *Gazette des Beaux-Arts* in 1882, early Ukiyo-e, engraved at the end of the seventeenth century, were considered "in their simplicity the product of an original art already completely sure of itself."

Gauguin succeeded in not only capturing the self-assurance of his primitive models but in infusing his prints with even greater expressive force by his coarse woodcutting methods. He was already an experienced woodworker; he had carved relief sculptures in Tahiti and in Brittany had adorned furniture, even his wooden shoes, with carvings. To prepare blocks for printing he used the same tools—a carpenter's chisel to scoop out large areas that were to print white and then a sharp knife to cut thin lines and detailed planes. He carved the blocks roughly, ignoring most of the refinements Japanese craftsmen had devel-

108 PAUL GAUGUIN

*Noa Noa (Oh, Fragrant Earth). Woodcut from a series of ten. About 1893–95*

The Metropolitan Museum of Art. Rogers Fund, 21.38.10

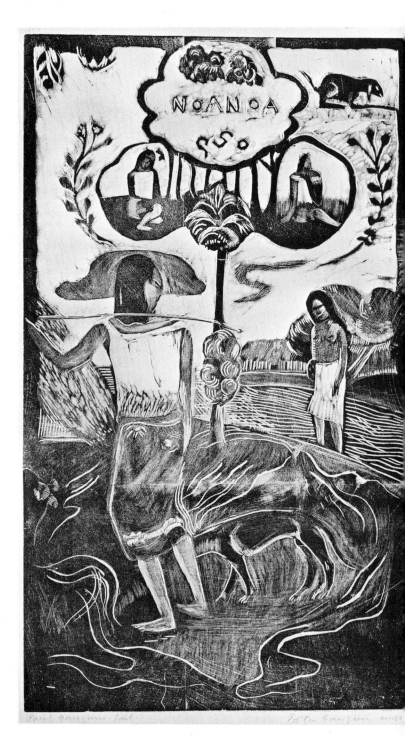

104

109 OKUMURA MASANOBU, 1691–1768

*Two men at a waterfall, one with a water buffalo. Woodcut*

The Metropolitan Museum of Art. The H. O. Havemeyer Collection.
Bequest of Mrs. H. O. Havemeyer, 1929. no. 1589

110 TORII KIYOHIRO

*The actor Segawa Sengyo (Kikujiro) as a young man.
Color woodcut. About 1750*

Ex. coll. Henri Vever

oped, although he placed the emphasis, as they
did, on startling contrasts of white and black, flat,
unbroken areas and textured ones.

In the design of his first *Noa Noa* woodcut
Gauguin followed a traditional Ukiyo-e upright
format, compressing into it successively receding
arched planes. Curvilinear shapes and decorative
abstractions of clouds, hills, and plant life activate
the entire picture surface. Though the strolling
native girl is typically Tahitian, Gauguin de-
scribed her natural elegance and the calm,
luxuriant South Seas landscape in Japanese terms
(*110*).

Further evidence of the eastern influence on Gauguin's prints is seen in two other *Noa Noa* plates, Auti Te Pape (Women at the River) (*111*) and Mahna No Varua Ino (The Demon Speaks) (*113*). In their dynamic compositions and striking textures Gauguin paid homage to the master Hokusai. Two of Hokusai's own prints adorn the manuscript of the *Noa Noa* journal (now in the Louvre); one is a page from volume 5 of the *Manga*, the other an illustration from volume 1 of *Ehon Wakan No Homari* (*Illustrations of Honorable Anecdotes of Japan and China*). In another journal, *Avant et Après*, Gauguin again collected Ukiyo-e prints [11] side by side with western works and explained his reasons:

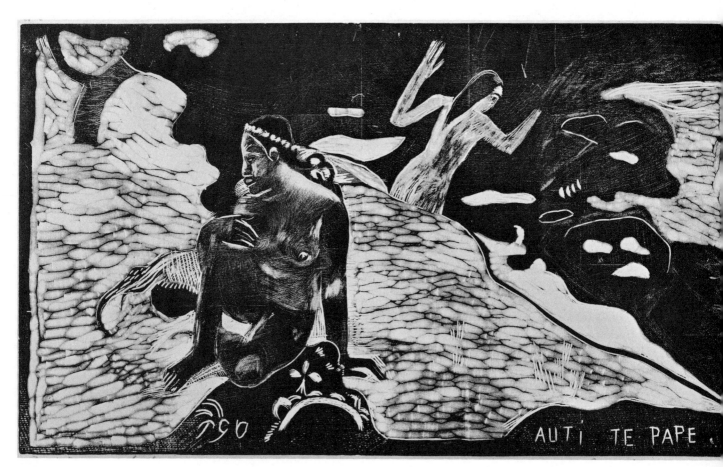

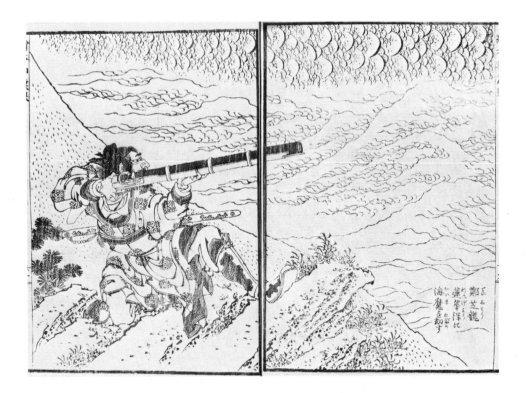

112 KATSUSHIKA HOKUSAI, 1760–1849

*Illustration from* Ehon Wakan No Homari (Illustrations of
Honorable Anecdotes of Japan and China), *vol. I. Woodcut*

The Metropolitan Museum of Art. The Howard Mansfield Collection. Gift of
Howard Mansfield, 1936. Japanese illustrated book no. 110

*Japanese sketches, prints of Hokusai, litho-
graphs of Daumier, cruel observations of
Forain—gathered together in an album, not by
chance but by my own deliberate will. . . .
Because they appear so very different I want
to demonstrate their bonds of relationship.*

*In this warrior of Hokusai, Raphael's St.
Michael has become Japanese. In another
drawing of his, he and Michael Angelo meet. . . .
Hokusai draws freely. To draw freely is not to
lie to oneself.*

Gauguin's admiration for Hokusai's powerful
images had prompted him to copy wrestlers from
the *Manga* in 1888, to draw on Hokusai's view of
the Hodogaya Station on the Tōkaidō Road for
his 1889 lithograph of Martinique, The Grass-
hoppers and the Ants, and, a decade later, to
model a woodcut of a horse for his South Seas

newspaper, *Le Sourire,* on the horse from
Hokusai's *Ehon Wakan No Homari.*[12] Since
Gauguin must have had a complete copy of
Hokusai's book, he could conveniently refer to one
of its compelling illustrations as he designed his
Auti Te Pape woodcut (*111*). Like other *Noa Noa*
plates, it is based on one of Gauguin's Tahitian
paintings (Fatata te Miti, 1892) and in conver-
sion from painting to print the composition was
condensed into a simpler image, based upon the
diagonal thrust and surface patterns of Hokusai's
print (*112*). The bold foreground figure is set
against rolling rhythms of mountain and sea,
dappled rocks and waves. Gauguin, whose artistic
credo was "Do not paint too much from nature.
Art is an abstraction. Seek it in nature by dream-
ing in the presence of it,..."[13] discarded naturalism
as it had been understood in Europe for centuries
in favor of oriental modes of abstraction.

*Mahna No Varua Ino (The Demon Speaks). Woodcut from a series of ten. About 1893–95*

The Metropolitan Museum of Art. Rogers Fund, 21.38.7

MAHNA NO VARUA INO

In the woodcut Mahna No Varua Ino (*113*) Gauguin, probably again motivated by Hokusai (*114*), incised wavering parallel lines to represent glowing reflections of firelight in smoke. Gauguin's mastery of oriental conventions is clearer still in the short essay "The Cloisonné Vases," from *Avant et Après*. To a description of a typical Japanese household and oriental cloisonné technique (both of which he had seen at the 1889 Universal Exposition) Gauguin appended these comments:

*[The Japanese] knows how to draw, not exactly as we do from nature; but every child is taught at school a general schema established according to the masters. Birds flying or at rest, houses, trees, everything in nature, in short, has an invariable form which the child quickly gets at his fingertips. Composition alone is not taught him, and every encouragement is given to the roving imagination.*

Gauguin's early attraction to Japanese prints was based on their clear outlines and pure colors

108

114 KATSUSHIKA HOKUSAI, 1760–1849

*Snow scene: hunters and foresters warming their hands at a log fire. Color woodcut from the series* The Hundred Poems Explained by the Nurse

The Metropolitan Museum of Art. The Henry L. Phillips Collection. Bequest of Henry L. Phillips, 1940. no. 2935

and their lack of naturalistic modeling and formal perspective—all those features that suggested "primitive" art. Moreover, the Ukiyo-e decorative subjects exerted an exotic charm on him. To Gauguin the Japanese penchant for illustrating nature by abstract formulas must have suggested the earliest forms of graphic expression, and the woodcut process seemed an especially primitive picture-making technique. As Gauguin's personal imagery became increasingly involved with "origins" and "basics," Ukiyo-e prints continued to compel him. Their wide range of expression—from subtle refinement to crude boldness—complemented his own shifts in temperament. Not until late in life did Gauguin remark on his conception of the Japanese people, from whom he had learned and taken so much: "In the spring they go out in couples, gay and happy, wandering through the flowering woods where, amid aphrodisiacal perfume, the senses regain their vigor" ("The Cloisonné Vases," *Avant et Après*). Obviously Gauguin thought the creators of Ukiyo-e

woodcuts were naïve, happy, sensuous, and un-spoiled by overcivilization—the ideal "primitives."

One of the latest nineteenth-century French artists to fall under Ukiyo-e's spell, Gauguin probed some of its earliest and most spirited images for elements with which to mold his own symbolic exploration of nature's mysteries. Japanese prints, in his hands, became ingredients in a powerful brew, heavier than the refreshing potion fashioned from impressionism's mingling with Ukiyo-e, and even more intoxicating.

1. Jean de Rotonchamp, *Paul Gauguin* (Paris, 1946), p. 143.

2. *Ibid.*, p. 68.

3. The manuscript of the journals Gauguin called *Avant et Après* (in the possession of Emil Gauguin in 1958) was published in a facsimile edition in Leipzig, 1918. This was later translated and edited by Van Wyck Brooks and published as Gauguin's *Intimate Journals* (Bloomington: Indiana University Press, 1958).

4. See "Inventaire des Biens de Gauguin," *Gazette des Beaux-Arts,* vol. 47 (January–April 1956), pp. 201–204. Two triptychs from his own collection were sold at auction after his death: Kunichika's Wrestlers and Kunifuku's Eagle with a Bear in its Talons, according to Jay Martin Kloner's unpublished doctoral dissertation, "The Influence of Japanese Prints on Edouard Manet and Paul Gauguin," (New York: Columbia University, 1968), p. 158.

5. Kloner, *op. cit.*, p. 146.

6. John Rewald in *Post-Impressionism, from Van Gogh to Gauguin* (New York, 1956), p. 442, suggests that the print is Kunichika's portrait of Hige no Ikyu, made about 1880.

7. Maurice Malingue, *Lettres de Gauguin* (Paris, 1946), p. 133.

8. Letters from Arles, 1888, quoted in Rewald, *op. cit.*, p. 198. Theo van Gogh wrote to his brother Vincent in October 1889 regretting the numerous "reminders of the Japanese" in Gauguin's work: "As far as I am concerned, I prefer to see a Breton woman from Brittany rather than a Breton woman with gestures of a Japanese. . . ."

9. Malingue, *op. cit.*, p. 193.

10. Richard Field correctly points to the somewhat earlier woodcuts of Auguste Lepère and Félix Vallotton, which Gauguin surely knew. See Field's thorough study of this series, "Gauguin's Noa Noa Suite," *The Burlington Magazine,* September 1968, pp. 500–511.

11. Kloner, *op. cit.*, pp. 155–56, attributes the three Japanese prints pasted on the inside covers and back flyleaf of *Avant et Après* to Kunitsuna II (about 1860). All three woodcuts show single female figures.

12. The comparison of Gauguin's title piece for "Le Sourire," December 1899, with Hokusai's woodcut is made by Jay Kloner, *op. cit.*, pp. 163–64. Gauguin may have been referring to his Hokusai model when he wrote in *Avant et Après*: "Sometimes I have gone far back, farther back than the horses of the Parthenon. . . ."

13. Malingue, *op. cit.*, letter LXVII to Émile Schuffenecker, August 14, 1888, p. 134.

# Selected Bibliography

Adhémar, Jean, *Toulouse-Lautrec, His Complete Lithographs and Drypoints,* New York, 1965.

Bénédite, Léonce, "Félix Bracquemond," *Art et Décoration,* XVII (February 1905), pp. 37–47.

——————, "Whistler," *Gazette des Beaux-Arts,* XXXIV (August 1905), pp. 142–58.

Bing, S., ed., *Le Japon Artistique,* vols. I–VI (May 1888–April 1891).

Breeskin, Adelyn D., *The Graphic Work of Mary Cassatt,* New York, 1948.

Chesneau, Ernest, "Le Japon à Paris," *Gazette des Beaux-Arts* (September 1878), pp. 385–97.

*Collection Ph. Burty; Catalogue de peintures et estampes japonaises, de miniatures indo-persanes et de livres relatifs à l'Orient et au Japon,* sale catalogue, Paris, 1891.

*Collection Hayashi; Estampes, Dessins, Livres illustrés,* sale catalogue, Paris, 1902.

Crighton, R. A., *The Floating World: Japanese Popular Prints, 1700–1900,* London: Victoria and Albert Museum, 1973.

Danielsson, Bengt, "The Exotic Sources of Gauguin's Art," *Gauguin and Exotic Art,* Santa Cruz (?): University of California, n.d.

Delteil, Loys, *Edgar Degas; Le Peintre-Graveur Illustré,* IX, Paris, 1919.

——————, *H. de Toulouse-Lautrec; Le Peintre-Graveur Illustré,* X, Paris, 1920.

Dorra, H. and S. C. Askin, "Seurat's *japonisme," Gazette des Beaux-Arts,* LXXIII (February 1969), pp. 81–91.

Duret, Théodore, "L'Art Japonais," "Hokusai," *Critique d'Avant-Garde,* Paris, 1885, pp. 132–244.

Focillon, Henri, *L'Estampe Japonaise et la Peinture en Occident dans la seconde moitié du XIXᵉ Siècle,* Paris, 1921.

Geffroy, Gustave, "Maitres Japonais," *La Vie Artistique,* I (1892), pp. 85–135.

Goldschmidt, Lucien and Herbert Schimmel, eds., *Unpublished Correspondence of Henri de Toulouse-Lautrec,* London, 1969.

de Goncourt, Edmond, *Hokousai,* Paris, 1896.

——————, *Outamaro, Le Peintre des Maisons Vertes,* Paris, 1891.

Gonse, Louis, *L'Art Japonais,* 2 vols., Paris, 1883.

——————, "L'Art Japonais et son influence sur le goût européen," *Revue des arts décoratifs,* 1898.

——————, *Catalogue de l'Exposition Rétrospective de l'Art Japonais,* Paris, 1883.

Gookin, Frederick W., *Illustrated Catalogue of Japanese Color Prints from the famous collection of the late Alexis Rouart,* sale catalogue, Paris, 1922.

Hahn, Ethel, "The Influence of the Art of the Far East on Nineteenth Century French Painters," unpublished M.A. thesis, University of Chicago, 1928.

Harris, Jean C., *Edouard Manet, Graphic Works: A Definitive Catalogue Raisonné,* New York, 1970.

Hillier, Jack, *Suzuki Harunobu,* Philadelphia Museum of Art, 1970.

——————, *Utamaro,* London, 1961.

Kloner, Jay Martin, "The Influence of Japanese Prints on Edouard Manet and Paul Gauguin," unpublished doctoral dissertation, New York: Columbia University, 1968.

——————, "Van Gogh and Oriental Art," unpublished M.A. thesis, New York: Columbia University, 1963.

Munich, Haus der Kunst, *World Cultures and Modern Art: The Encounter of 19th and 20th Century European Art and Music with Asia, Africa, Oceania, Afro- and Indo-America,* Siegfried Wichmann, organizer, Munich, 1972.

Muther, Richard, "The Influence of the Japanese," *The History of Modern Painting,* vol. III, London, 1907, pp. 81–104.

New York, Museum of Modern Art, *Bonnard and His Environment,* texts by James Thrall Soby, James Elliott, and Monroe Wheeler, New York, 1964.

Paris, École des Beaux-Arts, *Exposition de la Gravure Japonaise,* Paris, 1890.

Reidemeister, Leopold, *Der Japonismus in der Malerei und Graphik des 19. Jahrhunderts,* Berlin: Staatlichen Museum, 1965.

Rewald, John, *The History of Impressionism,* New York: The Museum of Modern Art, 1961.

——————, *Post-Impressionism, from Van Gogh to Gauguin,* New York: The Museum of Modern Art, 1962.

Rhys, Hedley H., "Afterword on Japanese Art and Influence," *Paris and the Arts from the Goncourt Journals,* trans. and ed. G. Becker and E. Philips, Ithaca: Cornell University Press, 1971.

Rich, Daniel Catton, "Notes on Sharaku's Influence on Modern Painting," *Chicago Art Institute Bulletin,* XXIX (January 1935), pp. 5–6.

Roger-Marx, Claude, *Bonnard, Lithographe,* Monte-Carlo, 1952.

——————, *L'Oeuvre Gravé de Vuillard,* Monte-Carlo, 1948.

Russell, John, *Vuillard,* Greenwich, Connecticut: New York Graphic Society, 1971.

Sandberg, John, "The Discovery of Japanese Prints in the Nineteenth Century, before 1867," *Gazette des Beaux-Arts,* LXXX (May 1968), pp. 295–302.

——————, "*Japonisme* and Whistler," *The Burlington Magazine,* CVI, 1964, pp. 500–507.

Sandblad, Nils Gösta, *Manet, Three Studies in Artistic Conception,* Lund, 1954, (Chapter on Manet's "Olympia," pp. 69–107).

Scheyer, Ernst, "Far Eastern Art and French Impressionism," *Art Quarterly,* VI, 1943, pp. 116–43.

Stern, Harold P., *Master Prints of Japan, Ukiyo-e Hanga,* New York, 1969.

Thirion, Yvonne, "L'Influence de l'Estampe Japonaise dans l'Oeuvre de Gauguin," *Gazette des Beaux-Arts,* XLVII (January–April 1956), pp. 95–114.

——————, "Le Japonisme en France dans la seconde moitié de XIX siècle, à la faveur de la diffusion de l'estampe Japonaise," *Cahiers de l'Association Internationale des Études Françaises,* XIII, 1961, pp. 117–30.

Weisberg, Gabriel P., "Félix Bracquemond and Japanese Influence in Ceramic Decoration," *Art Bulletin,* LI (September 1969), pp. 277–80.

——————, "Félix Bracquemond and *Japonisme*," *Art Quarterly,* XXXII (Spring 1969), pp. 57–58.

Yamada, Chisaburoh, *Mutual Influences between Japanese and Western Arts,* Tokyo, 1968.